BASICS
PHOTOGRAPHY
01

COMPOSITION

2nd edition

Ethical: aware-
ness/
reflect-
ion/
debate

ava
academia

An AVA Book

Published by AVA Publishing SA
Rue des Fontenailles 16
Case Postale
1000 Lausanne 6
Switzerland
Tel: +41 786 005 109
Email: enquiries@avabooks.com

Distributed by Thames & Hudson (ex-North America)
181a High Holborn
London WC1V 7QX
United Kingdom
Tel: +44 20 7845 5000
Fax: +44 20 7845 5055
Email: sales@thameshudson.co.uk
www.thamesandhudson.com

Distributed in the USA & Canada by:
Ingram Publisher Services Inc.
1 Ingram Blvd.
La Vergne TN 37086
USA
Tel: +1 866 400 5351
Fax: +1 800 838 1149
Email: customer.service@ingrampublisherservices.com

English Language Support Office
AVA Publishing (UK) Ltd.
Tel: +44 1903 204 455
Email: enquiries@avabooks.com

Second edition © AVA Publishing SA 2012
First published in 2006

ISBN 978-2-940411-77-1

Library of Congress Cataloguing-in-Publication Data
Präkel, David.
Basics Photography 01: Composition / David Präkel. p. cm.
Includes bibliographical references and index.
ISBN: 9782940411771 (pbk. :alk. paper)
eISBN: 9782940447411
1. Composition (Photography).
TR685 .P745 2012

10 9 8 7 6 5 4 3 2 1

Design by Gavin Ambrose
Illustrations by David Präkel
Cover image by Caroline Leeming

Production by AVA Book Production Pte. Ltd., Singapore
Tel: +65 6334 8173
Fax: +65 6259 9830
Email: production@avabooks.com.sg

Printed in China

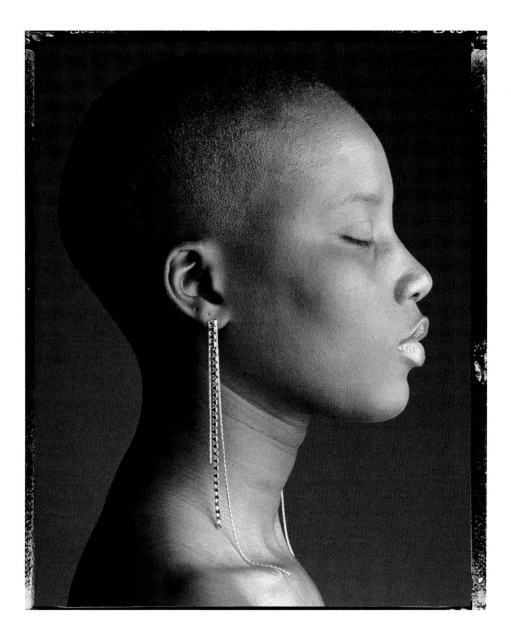

Binette 12 (above)

The simple composition of this portrait emphasizes the beautiful, bold, graphic shape, texture and lighting of the subject's features.

Photographer: Nana Sousa Dias.

Technical summary: Pentax 645 with Pentax 135mm macro lens, 1/60 at f/22, Ilford HP5 Plus, lit by Multiblitz Magnolite 32 flash-head with 1m square softbox.

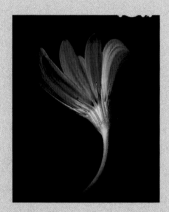
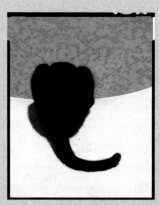
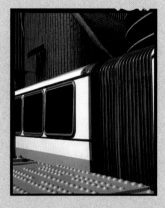

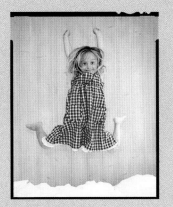 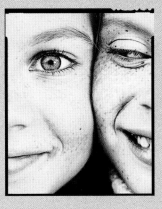

The best photographic images combine technical excellence with strong composition. Though not everyone would agree about the process of composition, all would agree an image is stronger for its use. Photographic technique may be complex, but its application is methodical and the outcome predictable. Composition, in contrast, requires discrimination and the exercise of personal taste. It is a difficult subject, especially for those beginning to explore photography as a profession or art form.

Many photographers initially look for a composition checklist or book of rules that will match the predictability of photographic technique. The first rule of composition is there are no rules. While technique can be seen as a series of points for consideration or action in turn (focus, exposure, etc.) it is not possible to do this with composition. Creating a powerful image cannot follow a checklist approach – it must be holistic. Understanding that the eye and the camera 'see' things quite differently is key to this.

We can do this by experimenting with the isolated formal elements and by looking at the widest possible range of well-composed images. Through its structured texts and careful choice of imagery, case studies and exercises, this book will kick-start these processes.

Basics

For a viewer to make sense of an image it must be well composed. This section looks at the need for organization and at ideas from the art world that have dominated photographic thinking in the past.

Formal elements

If composition is the underlying grammar of a visual language, then the seven formal elements – line, shape, tone and form, texture, space and colour – are its vocabulary.

Organizing space

Creating a photographic image is to put a frame around a chosen subject. The proportions of that frame and where the subject is placed within, influence how an image is 'read'. The photograph's unique ability to manipulate the appearance of space is examined in this section.

Organizing time

By definition, still photography captures the moving world in a static image. Photographers have the choice of smearing passing time or freezing the action. In this chapter, image sequencing and choosing the peak moment to trip the shutter are explored.

Originality

Putting over your own vision is important. This section discusses ways to develop a personal photographic style and how to produce powerful images by 'breaking the rules'.

Application

Major forms of photography involve different approaches to composition. This final section makes suggestions for fine art, landscape, the nude and portraiture as well as for news, advertising and sports photography, where composition may not always be considered a central contributing factor.

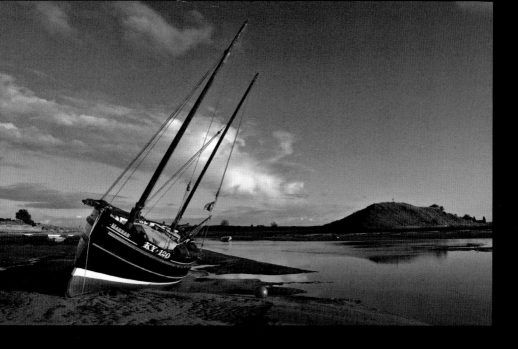

Alnmouth, Northumberland (above)

This image represents the best-composed shot from a sequence taken at the same time. The compositional elements work in harmony.

Photographer: David Präkel.

Technical summary: Nikon D100 18–35mm f/3.5-4.5D AF ED Zoom-Nikkor at 18mm (27mm 35mm equivalent); 1/320 at f/9 ISO 200.

Making pictures

Whether you choose the subject or the subject chooses you, the process of picture making begins. Composition involves everything that goes into creating an image. The process starts with consideration and exploration of the subject. It continues with selection, it involves analysis and only concludes when the viewer's gaze falls on the finished image. Given an infinite number of potential images, composition provides a working method to analyse the subject in terms of its visual attributes, to understand these in light of one's personal feelings and motivations and then to arrange the elements into a coherent whole – a unique image. Photography is not just the recording or depiction of reality. Because photographers must exercise choice in selecting part of the real world to frame, composition becomes the expression of their personality.

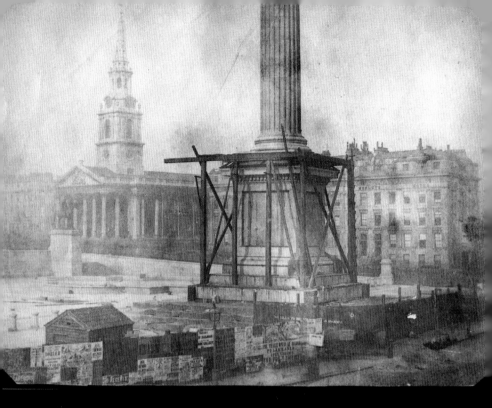

Nelson's Column under construction, Trafalgar Square, London, 1844 (above)
Taken only five years after Fox Talbot's announcement of his successful photographic
experiments, this image already makes a powerful compositional statement about what
photography already is, why it is not painting and what it will become.

Photographer: William Henry Fox Talbot.

Technical summary: 17 x 21cm salted paper print from a calotype negative. National Media Museum Collection.

Basics

Composition, when understood as the pleasing arrangement of the elements of a photograph, has preoccupied the photographic practitioner since the earliest days of photography in the mid-nineteenth century. The pictorialists adopted the stance that art photography needed to follow the compositional rules of painting and illustration. Their influence is still felt. But there is already a clear indication in the photographs of certain pioneers (like Fox-Talbot and Fenton), which have a disturbing and anachronistic modernist quality, that photography is a unique medium in its own right. Photography shares only certain things with painting and is the lesser for being dominated by the principles of painterly composition.

Today, photography is democratized in a way that art never has been. Anyone can be an image-maker. The history of the 'snapshot' is as long as the history of modern photography itself, most taken by people with little formal appreciation of the rules of composition. In postmodern fashion, the casual snapshot has been appropriated by photographers and photographic artists who have knowingly hijacked it for creative ends. The sheer ubiquity of the photographic image in news media, advertising and commerce boldly sidelines historic notions of fine art, creating opportunities for new kinds of composition, though sometimes more stylized than before.

The rules of composition give photographers an organizing principle and strength, but they can also be an artistic straitjacket, inhibiting creativity, and can lead to stereotypical images. Many of the so-called 'rules' of composition are based on an analysis of what the establishment and practitioners alike have traditionally considered to be effective images rather than on scientific experiment or survey.

This chapter looks at motivation and the psychology of photography and investigates the difference between a snapshot and a formally composed image. It also looks at some of the fine-art concepts that continue to be applied to photography and discusses which are and which aren't relevant.

'There is a vast difference between taking a picture and making a photograph.' Robert Heinecken (American photographer)

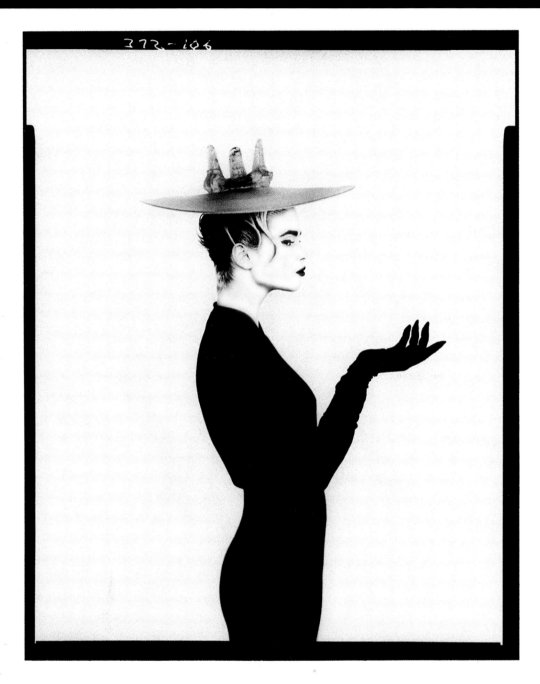

The case for composition

What is the purpose of a photographic image? We make photographs to share experiences, to show people things that they would otherwise not see, and to say something about the world or the self that cannot be better said in words.

Composition is the process of identifying and arranging visual elements to produce a coherent image. Everything in an image forms its 'composition'. Learning composition is like learning a language. Once you've learned a language, it is not something you consciously think about as you talk. Photographers should aim to become fluent in the language of composition.

We react to objects in photographs much as we do to the real thing. There is a crude equation: the stronger our reaction, the better the image. How do we know this? Graphic news images of a wounded and dying soldier will make you shudder. If we did not understand the object in the image as being another human being, we would simply see the photograph as a study in red, pink and khaki. Composition is a structured process, but, with familiarity, it becomes fluid and unconscious in its application. It needs emotion to feed on – without emotion it can create superficially pleasing, but meaningless images.

To enable us to better understand the principles of composition, the constituent parts of an image must be formally broken down into line, shape, tone and form, texture, space and colour. While it is most expedient to study these elements in isolation, composition is the process of combining them – like ingredients in a recipe. The camera will rarely encounter one of the elements in isolation. In approaching any subject, the photographer must first discover the constituent elements of the scene presented to their camera. The process of deciding how to balance and blend the elements of composition can then begin.

'Geometry is to the visual arts what grammar is to the art of the writer.' Guillaume Apollinaire (author and friend of cubist painters)

Plate (facing opposite)

Black and white exaggerates shape, tone and form. The three fingers of the hand mirror the three points on the plate being 'worn' as a hat. Choosing the precise 'moment' creates a distinctive sense of quirky elegance for this classy subject.

Photographer: Jim Allen.

Technical summary: Sinar P 5 x 4, 210mm Nikkor f/5.6, Kodak Tri-X, lit by north light against a white wall.

The case for composition The rules »

Selection and arrangement

The eye and camera do not 'see' the same things. The brain actively and constantly processes information from the eyes, cutting out unwanted detail that, in the camera's passive view, gets equal prominence.

If someone intends to take a photograph, they carry a camera. What catches their eye depends entirely on their reason for carrying the camera – perhaps an interest in people or landscape. When something grabs their attention, they stop, bring the camera up to eye level and press the shutter as their emotions peak. Images taken this way often disappoint; if printed or shown to others, they are usually accompanied by an explanation of the events they were meant to depict.

What goes wrong is that the camera is being used to record the unrecordable – the shutter released in an effort to capture a composite thought or personal reflection on a scene or event. The image, in other words, has not been composed. Constituent parts that identify and meaningfully bring together the message for the viewer have not been captured, leaving the meaning unclear.

A fundamental lesson to learn is that it is all too easy to make a photograph that coincides with your frame of mind at the instant you pressed the shutter. Composition helps you deal with what is in front of the camera in light of your ideas and feelings.

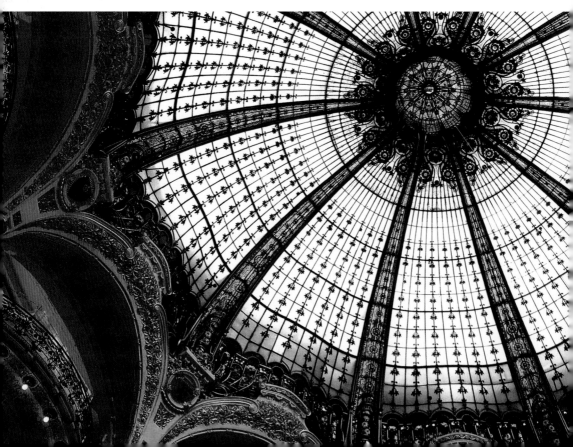

Paintings and photography

Drawing, painting and the process of photography have certain things in common. Each attempts to stop the living world and frame it in two dimensions. The world is a dynamic place where people and objects move in three dimensions. In contrast, photographs and paintings not only 'stop the clock', but also draw the viewer's attention to a framed part of the world, where spatial relationships are now frozen into a specific two-dimensional representation. In both painting and photography, dynamic becomes static and the three-dimensional world becomes flattened into two.

The artist constructs, works and reworks the image within its frame – referring back to the real world or maybe working with pure imagination. Their image can always be revised or changed. In contrast, the photographer frames part of the world, organizing subject matter within that frame. Alternative processes and digital manipulation offer some degree of image reworking, but – if it's not to be called digital art – the raw material of the photograph comes from that first selection made from the real world.

'It takes a lot of imagination to be a good photographer. You need less imagination to be a painter, because you can invent things.' David Bailey (British photographer)

Galeries LaFayette (facing opposite)

From the riot of potential colourful subject matter in the Galeries Lafayette Haussmann store in Paris, the photographer has selected the shape and pattern of the glass dome, carefully positioning it in the frame to include some of the rich colours and contrasting scalloped shapes of the arcade.

Photographer: Bjørn Rannestad.

Technical summary: Sony DSC-V1, 1/80 at f/2.8, ISO 100.

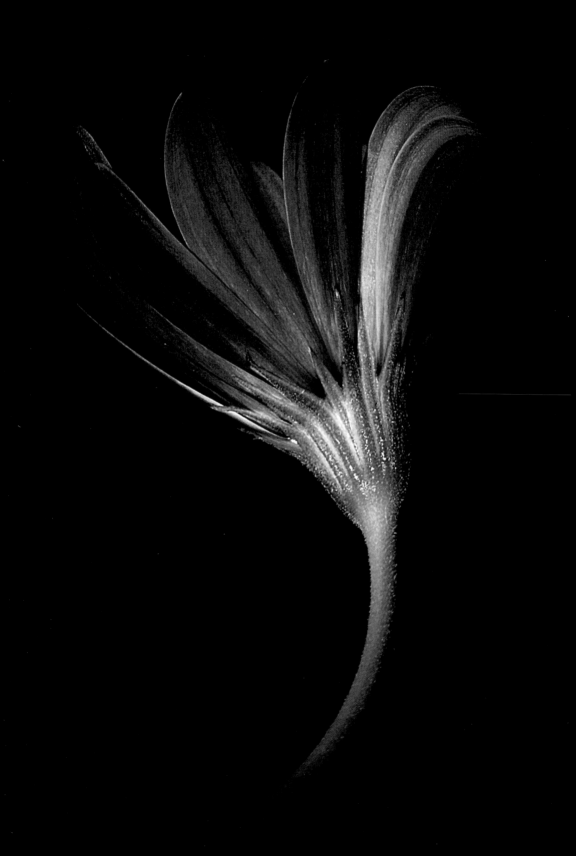

The rules

Often, photographers have borrowed ideas from the fine arts and struggled to apply rules of composition that were, for them, only of use after the fact as a tool to analyse the finished image rather than create it.

Painting and drawing are a synthesis of what has already been seen, expressed on canvas or paper. Even when working from life, the artist can include items from his or her imagination and can edit out details or whole sections of the scene, something the photographer can only do to a limited extent. A photographer cannot simply decide not to photograph something that is already in the frame, although image editing software has allowed greater freedoms. Painting and drawing are the arts of constructing an image, but photography is the art of selection. Classical artists would strive to achieve harmony, balance and a beauty that transcends the real world. Photography so often is the real world.

The artist is free to rearrange the proportions and elements of the scene while painting, so that they fall harmoniously on the canvas. Precise geometry can be used to place key components. Much of this process comes from an awareness of classical proportion and the embedding of basic shapes, such as triangles and circles, into the composition.

To cover a canvas randomly with a range of coloured paints would take many times longer than it does to take a photograph. Most artists work their paintings for many hours and the images will evolve during this process. For the photographer, the moment they press the shutter is usually the culmination of the compositional and artistic act. There are photographers who will have nothing to do with darkroom enhancement or digital manipulation. Post-processing does offer some scope for further expressivity, but the results should always be pre-visualized and post-processing undertaken in a way to achieve that expression.

'The significant difference between photography and other art forms is its unique ability to record simply and in unbiased detail, something that is there.'
(unattributed)

Single beauty (facing opposite)
The crisp detail and strong blocks of colour that stand out from the solid black background make this single flower 'hyper real'. Strong central lighting and the forward curve of the stem and petals increase this sense of 'presence'.

Photographer: Markos Berndt.

Technical summary: Minolta Dimage 7i with close-up lens, 39 sec, shot in a dark room on black background with a flashlight.

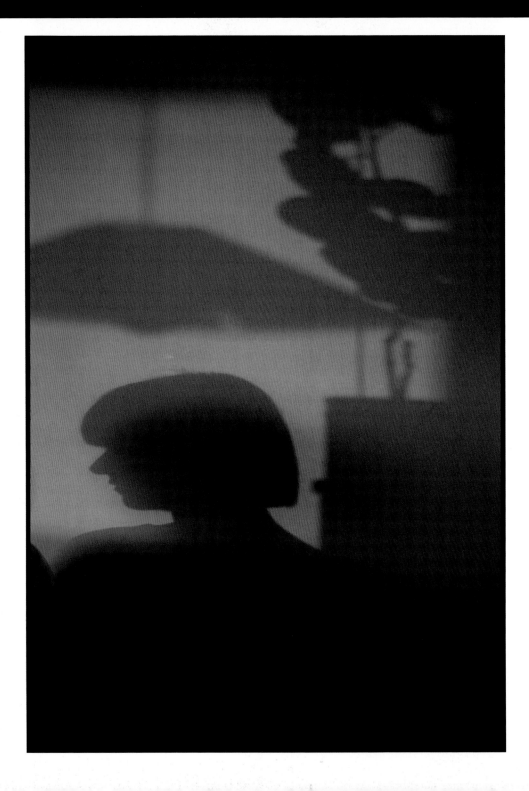

Keeping it simple

Composition is the mental editing process a photographer applies as they work on an image to make its message easier for the viewer to read. A common mistake is to think about what to 'put into' a picture. For the beginner in photography the temptation is to try to give an image import by filling it with as much detail as possible. Instead, thinking about 'what can be left out' of a picture will strengthen it. Look for the simplest theme. Simplification is an essential part of composition; getting rid of unwanted visual clutter leaves only the important elements that can then be arranged to create a well-composed image.

Photographers can pay too much attention to the subject and neglect to check for potential clutter in the background. The result is a badly organized image. A quick visual check around the edges of the subject will make certain that nothing distracting or unwanted interferes.

In-camera cropping is an often-overlooked solution to the problem of simplifying an image. A zoom lens can crop the image without changing perspective as long as the photographer and subject stay put. Moving in closer fills the frame, emphasizes the subject and cuts out the background.

This simple technique seems surprisingly difficult for beginners to adopt.

It may not be possible to simplify the image by moving viewpoint or recomposing the image in the frame. The opportunity then presents itself to use photographic techniques such as selective focus or choosing a shallower depth of field (wider lens aperture). It may be possible to light the subject in such a way that it throws unwanted detail into deep shadow or, conversely, floods it with light.

There are numerous techniques to simplify images. Images can be simplified tonally by reducing or altogether removing the colour in an image by using monochromatic (black-and-white) film. Alternatively, using a high- or low-key approach can be effective. This means putting the subject in a setting with light (high-key) or dark (low-key) tones. Reducing colour in an image may be possible by taking the photograph during certain atmospheric conditions (rain or mist) or by using a diffusion or fog filter on the lens. Limiting the colour palette and similar effects, such as hand colouring, can be achieved during processing or by choosing to desaturate the colours. These techniques will be covered elsewhere later in the book (see pages 78–81).

Shadow portrait (facing opposite)

An exercise in ultimate simplification where the subject has been removed altogether. Strong natural frontal lighting from a large, uncluttered window produces a well-defined shadow on the wall beside the subject, making this the focus of attention. Despite the silhouette, the image remains a portrait as it conveys both the mood and character of the sitter. Enough details of the setting are retained. The limited palette of rich colours comes from the late afternoon sun falling on a painted wall.

Photographer: David Präkel.

Technical summary: Nikon F2A 135mm Nikkor, f/2.8 exposure not recorded, Ektachrome 64.

The golden section

Leonardo Pisano – also called Fibonacci – was a twelfth-century Italian mathematician, best known for his discovery of a remarkable sequence of numbers. This simple numerical series starts with 0 and 1. Adding the previous two numbers in the sequence together produces the next number in the series, hence the Fibonacci numbers: 0, 1, 1, 2, 3, 5, 8, 13, 21, 34, 55, 89, 144, etc.

The ratio of each successive pair of numbers in the series (5 divided by 3, for example, is 1.666, and 8 divided by 5 is 1.6) approximates to the 'Golden number' (1.618034), identified by the Greek letter Phi. Phi was considered the key to the secrets of heavenly mathematics. It relates to proportion, too. The golden number does not provide a magical solution to all problems of composition. Though people prefer the shape of an empty rectangle constructed around golden number proportions (1:1.618), this does not work for images cropped in these proportions where the image content has a great influence. However, it does appear that we are intuitively aware that nature is closely linked with the mathematics of sequences such as Fibonacci's and that it complies with our sense of harmony and proportion.

The golden section is a division based on the golden number proportion and can be used as a method for placing the subject in an image or of dividing a composition into pleasing proportions. It is easier to remember a ratio of 5:8 than it is 1.618, but it is much the same thing. Choosing where to put the horizon, fixing the main point of interest of dividing a frame into pleasing proportions can all be done in this ratio – although of course it does not guarantee the quality of the final image.

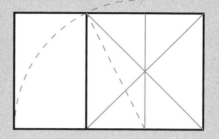

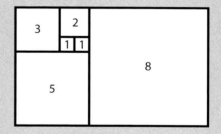

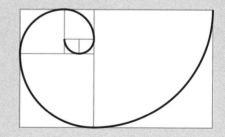

Golden number diagrams (above)
In this sequence of diagrams, the first (top) is constructed using the golden number proportions. The second (middle) builds a rectangle with squares based on the Fibonacci sequence. The third (bottom) shows a natural growth spiral that appeals to our sense of harmony.

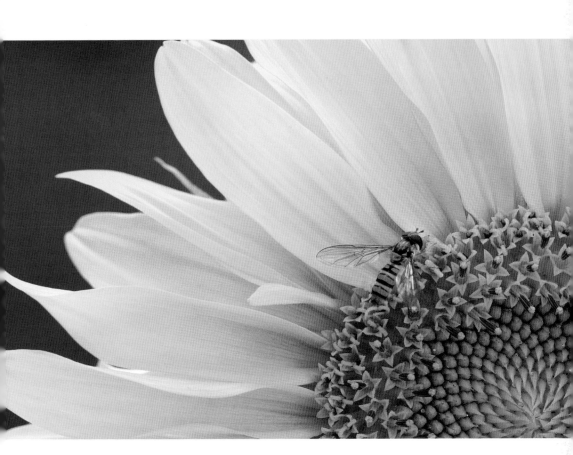

Sunflower (above)

Spirals based on the Fibonacci sequence underpin the distribution of seeds in the head of this sunflower. Plant growth, the formation of seashells – even the proportions of our bodies, reflect similar mathematical progressions.

Photographer: Nina Indset Andersen.

Technical summary: No camera details. Taken on a sunny afternoon with the sun behind and to the left. A silver reflector was used to bounce light onto the subject. The blue background was originally green, but was altered in Photoshop.

Deliberate composition using dynamic symmetry (above)

The areas and intersections of the dynamic symmetry grid used to position a flower within the camera viewfinder. The compositional technique is hinted at in the deliberately placed zigzag shadows on the backcloth.

Photographer: David Präkel.

Technical summary: Nikon D100 60mm f/2.8D AF Micro, 1/250 at f/8, ISO 200.

The rule of thirds

The rule of thirds is little more than a simplification of the proportions of the golden section, but is more widely used by photographers. Applying the rule of thirds, the centre of interest should be placed at the intersection of lines that divide the frame into thirds from top to bottom and from left to right. The rule of thirds is a useful aid for establishing compositional structure in an image, but is too regular in its proportions to produce very exciting results.

Some camera manufacturers offer a range of grids in the viewfinder or on the display screens to help the photographer with composition; some feature the conventional rule of thirds grid; others offer a grid based on a four-by-four grid, which is less useful for geometric composition, although any grid provides a useful means of squaring up the camera to buildings or to the horizon line.

Dynamic symmetry

An alternative way of organizing the centre of interest in a composition is to use dynamic symmetry. This is based on the proportions of the golden section, but determines the best place for the point of interest using diagonals rather than a grid, which some photographers find easier to visualize. Whatever the aspect ratio of the format used, draw a diagonal from one corner of the frame to the other. Then picture a line that runs at right angles to the first. With some trial and error, it becomes second nature to place subjects close to these points in the camera frame – it is important to think consciously about their precise placement if you change formats.

These geometric aids are often more useful after the fact, for cropping. Some photographers use acetate sheets with lines superimposed on them to indicate alternatives for cropping prints. These lines could also be drawn up in image-editing software as a template and used as a temporary layer to achieve a better crop.

Thirds and dynamic symmetry (below)

The four 'hotspots' to locate the centre of interest as suggested by the rule of thirds, which can be too regular to be visually exciting.

The rule of thirds grid can be used to locate subjects that join or overlap one or more 'hotspots'.

The centres of interest in an image using dynamic symmetry are less centrally positioned. Only one construction line is shown here.

« The case for composition **The rules** Viewpoint »

Viewpoint

The same scene can look very different in images taken from a high versus a low viewpoint. If you imagine once again lining up your camera to take a snapshot, the camera is brought up to eye level, pointing in the general direction of the subject and an exposure is made.

So many images are taken from eye level with little consideration of the alternatives. Eye-level shots produce images with a repetitive viewpoint. In contrast, images taken on cameras with waist-level finders (old twin-lens reflex models, for example) have a distinctly different feel because of the lower viewpoint. If your digital camera has a swivel screen, use it to help you get different viewpoints.

Choosing alternative viewpoints can show mundane objects in a new or revealing way. This is one of the primary ways in which a photographer can explore a subject. A low viewpoint can include and emphasize the foreground, leading the gaze into the image from the bottom. High viewpoints can detach the viewer from the action as the gaze is forced to look downwards into the image. Extremes of high and low viewpoints can have a dislocating, but invigorating effect. Simply moving viewpoint by shifting to one side or another – rather than moving the viewpoint up or down – can create juxtapositions that might also otherwise go unnoticed.

Even from the same viewpoint, the horizon can be placed high or low in the image. This will have a dramatic effect on the interpretation of the image by the viewer. A photograph of a small farm in the landscape can become either a tiny human dwelling beneath expansive skies or, conversely, a prominent farmhouse dominating acres of fertile land; depending on whether the horizon is set low or high in the frame. Think carefully what you want to say about a place before you decide where to put the horizon line.

'Our life is frittered away by detail…simplify, simplify.'
Henry David Thoreau (American philosopher and author)

Spiral (facing opposite)
A viewpoint directly at the centre of a stone spiral staircase emphasizes perspective, depth and its repeating pattern.
Photographer: Tiago Estima.
Technical summary: Canon EOS 300D, Tamron 17–35mm SP AF f/2.8–4 zoom, 1/50 at f/4, ISO 200.

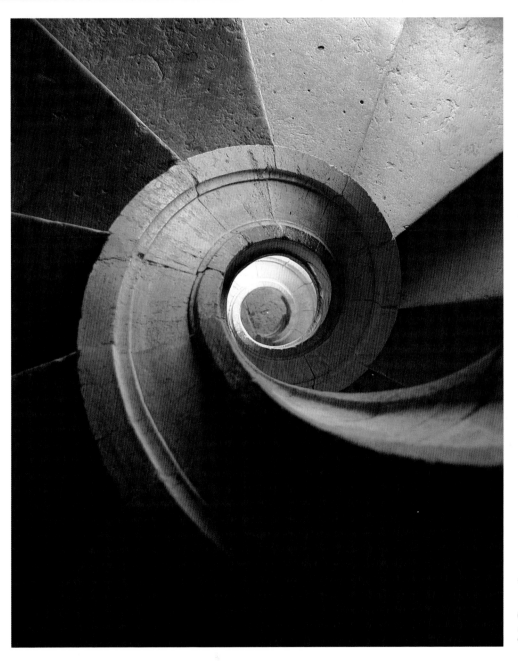

Perspective

We know that the two parallel kerbs of a road do not meet in the distance but, to give the appearance of depth in an image, that is how we draw or paint them. This is described as 'linear perspective'. The 'vanishing point' is the point in the far distance where the lines appear to meet.

Choice of viewpoint and lens focal length are major factors in the representation of depth or perspective in an image. The closer the viewpoint is to the subject, the larger it will appear in relation to more distant objects. When there are no obvious receding lines, we pick up clues to the representation of depth in a two-dimensional image in a number of ways – for example, the relative size of an object, repeating elements becoming smaller, and the appearance of patterns or textures.

Roads and paths are represented in images as strongly angled converging lines. Any path that recedes into the image from left to right goes with the natural scanning of the eye and seems to take the gaze to its destination.

Buildings show the same effect where their parallel sides appear to come together; this is called 'converging verticals'. This is the inevitable result of a ground-level viewpoint. Convergence can be corrected by using a camera with a rising lens panel or a shift lens, though some small degree of convergence is needed to stop the building from looking distorted. The application of image-editing software enables a degree of correction with minimal sacrifice of quality. However, an alternative is to stress the converging verticals in the composition and exaggerate them by choosing a wide-angle lens and tipping the camera back.

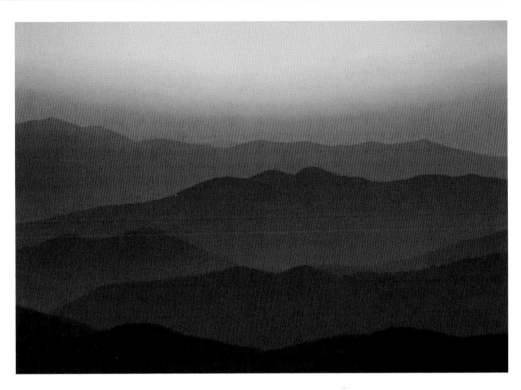

Smoky mountain sunset (above)

Aerial perspective is where distant hills are seen as lighter tones through the depths of a misty atmosphere, and overlying foreground shapes are much darker – a technique often used by Chinese artists to build depth into images. Mist and fog emphasize the effect.

Photographer: Cindy Quinn.

Technical summary: Nikon D100 with 3-stop hard GND filter, 1/8 at f/22, ISO 200, spotted for sensor dust and contrast and saturation adjusted in Photoshop.

Underground jungle (facing opposite)

Repeated and diminishing shapes and strong perspective lines produce a great sense of depth. The viewpoint puts the vanishing point dead centre, further emphasizing the perspective.

Photographer: Alec Ee.

Technical summary: Nikon D70 18-70mm f/3.5-4.5G AF-S DX IF-ED Zoom-Nikkor, ISO 200 with slight brightness and contrast adjustment in Photoshop.

Perspective and the face

Lenses of different focal lengths can be used to produce radically different images of the human face. When taking portraits it is important to consider the effect that lens focal length has on the proportions of the face. It is no coincidence that short telephoto lenses used to be called 'portrait' lenses.

These lenses depict the face with a flattering perspective close to the way we see faces when standing at a comfortable distance – in other words, without invading the subject's personal space. Lenses for full-frame digital SLRs and 35mm cameras in the range 75–105mm are ideal for portraiture, and when a human head and shoulders is framed in-camera they give a good natural perspective. These semi-telephoto lenses have the additional advantage of apparently shallower depth of field. This means that at most working apertures the background is thrown out of focus. Another reason these lenses work well for portraiture is that they allow the photographer a good working distance from the subject. An intimate portrait becomes possible without entering the personal space of the sitter, who will remain relaxed and look at ease in the final image.

Lenses with a longer focal length than 'portrait' lenses will foreshorten the perspective and give faces a flattened 'pancake' look. On the other hand, the disadvantage of wide-angle lenses is that the photographer must be physically closer to the subject to get a frame-filling portrait, which will then emphasize the part of the face closest to the camera. Viewers tend to find such images alienating. This is why compact cameras with fixed focal-length lenses are ideal for landscapes, but produce unflattering portraits. If you are working with a zoom lens, choose the telephoto end of the zoom range to take the best portraits.

Focal length and portraiture (facing opposite)

Lenses in the focal-length range 70–105mm (35mm equivalents) give the face the proportions we expect from looking at another person while standing at a comfortable distance from them. Lenses of these focal lengths used to be called 'portrait' lenses. To keep the same size head and shoulders portrait with a wide-angle lens the camera must be closer to the subject, which introduces an unpleasant distortion in the proportions of the face. Similarly, a telephoto lens will flatten the perspective of the face.

Photographer: David Präkel.

Technical summary: Nikon D100 various Nikon zoom and fixed focal length lenses and exposures, ISO 200.

28mm

50mm

90mm

180mm

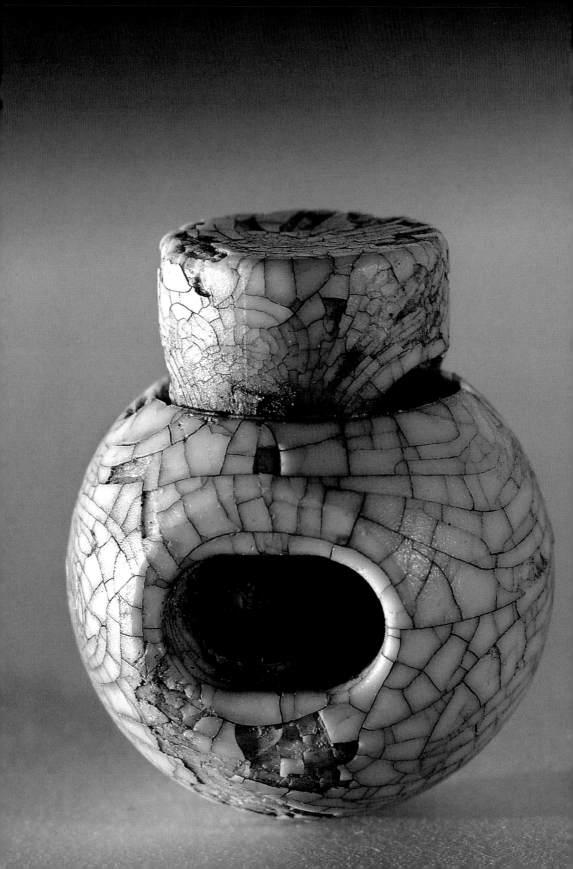

Scale

Size and scale offer lots of creative opportunities for inventive photographers. People are fascinated by extremes of size, and despite its reputation for never lying, since the earliest days of photography the camera has been used to produce images that diminish or exaggerate size.

We get our clues to size by comparison with identifiable objects in an image. Without clues to size the viewer doesn't have a reference point, and he or she must guess as to whether a thing is large or small.

Landscape photographers sometimes use this technique to interesting effect by excluding the horizon from their images and framing an edited portion of the landscape, creating a world in which scale is ambiguous.

Photographers have often wilfully misled the viewer in interpreting size. Irving Penn and Patrick Tosani created images of everyday objects, such as cigarette butts and spoons. In their carefully lit close-ups these mundane items take on iconic, classic qualities, far removed from their everyday functions.

Artefact (facing opposite)

Mexican jade pot? Archaeological artefact? Choice of lighting, viewpoint and lack of reference to size and scale make this item appear much bigger and grander than it really is – a 2cm-tall, plastic anorak toggle found buried in a garden, aged by sunlight and soil!

Photographer: David Präkel.

Technical summary: Nikon D100 60mm f/2.8D AF Micro, 1/180 at f/19, two flash heads with diffusers.

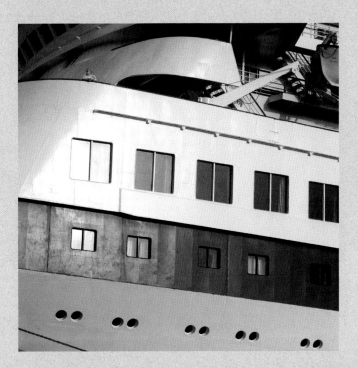

Woman and ship (left)

The massive size of this cruise liner would not be apparent if it were not for the tiny passenger seen top left – in fact, without this reference point for scale you could mistake the liner for a model. Corfu Town, Greece.

Photographer: Stephen Coll.

Technical summary: Bronica S2a Nikkor-P 200mm, exposure not recorded, Fuji Provia F 200.

Simplify, simplify, simplify

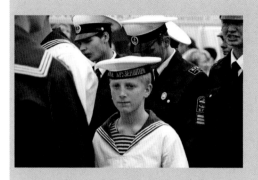

Boy sailor – the snapshot (above)

The young Russian naval cadet centred in the frame does not stand out sufficiently from the other sailors. There are several distracting elements: the white shapes in the background, the shoulder of the foreground sailor, the faces in the top right-hand corner of the frame and the sailor's face cut into the cadet's cap.

Photographer: David Präkel.

Technical summary: Nikon D100 70-300mm f/4-5.6D AF ED Zoom-Nikkor at 100mm (150mm 35mm equivalent), 1/250 at f/4.2, ISO 200.

At first, many photographers are tempted to pack as much as possible into their images, but the experienced worker knows the real trick is to choose what to leave out. This conscious editing of the scene becomes a curiously satisfying approach that only comes with practice, reflection and experience. Always consider what can be edited out of the image to simplify and strengthen your message. (Moving in closer is usually the best advice.)

When a photographer first realizes the benefits of structuring an image as a way of putting over meaning, they begin consciously to select, frame and arrange. With practice, this becomes second nature. Technical mastery is as important as composition, because the strongest message can only be revealed through a combination of strong composition and skilful photographic technique. You know you have succeeded when you can look back at an image and see that all the elements have a specific function.

A good place to practise these skills is at a big public event. There are scenes being set, characters on show and dramas unfolding everywhere you look. A photographer has to think and act quickly. These images were taken during a visit of the 'Tall Ships', as the naval cadets who crew these sailing vessels from all over the world formed up to parade.

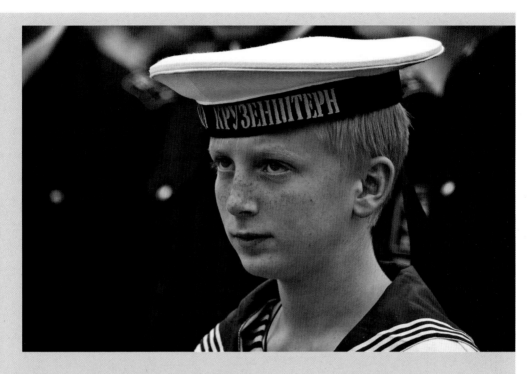

Boy sailor – the composed image (above)

Shifting the viewpoint to the right, along with the use of zoom, lets the scene be cropped in-camera, cutting out distracting faces in the background. Longer focal length meant care was needed to avoid shake with a slower shutter speed and to use limited depth of field effectively. Timing was critical to catch the expression, the eyes coming up as the cadet listens intently to the orders from his commanding officer. The space in front of the face implies his presence.

Photographer: David Präkel.

Technical summary: Nikon D100 with 70-300mm f/4-5.6D AF ED Zoom-Nikkor at 180mm (270mm 35mm equivalent) 1/180 at f/4.8 ISO 200.

'What you see in the photograph isn't what you saw at the time. The real skill of photography is organized visual lying.' Terence Donovan (British photographer)

Formal perspective gives artists a way to represent depth in their images, to realistically portray the third dimension on the flat surface of their canvas or paper. The so-called 'standard lens' is the focal length that offers the closest perspective to 'normal' vision when viewed on a 10 x 8in print held at arm's length. 50mm is the normal 'standard' lens for full-frame digital and 35mm film cameras giving an angle of view of 39°.

Nowadays, we are used to interpreting images and accept even extreme lens perspective in photographs. Most people are happy to accommodate the foreshortened perspective of the long focal length lens or even the distinctive circular images produced by an ultra wide-angle fisheye lens.

A telephoto lens will flatten perspective and appear to bring foreground and background closer together. To embed an object in the environment, a telephoto lens can be used to collapse perspective; very long focal-length lenses can produce apparent relationships between objects that are, in reality, quite far apart. In contrast, a wide-angle lens makes foreground objects appear much bigger than they are, and including a great deal of the background emphasizes perspective effects. Zoom lenses are simply lenses with variable focal length; fixed focal length lenses are described as 'prime lenses'.

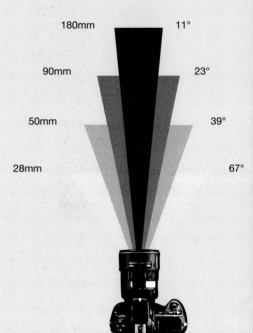

Angles of view (above)
Angles of view of wide (28mm), 'standard' (50mm), 'portrait' (90mm) and telephoto (180mm) focal lengths.

28mm

50mm

90mm

180mm

This exercise can be done with either a range of primes or a zoom lens and explores two situations. Position your camera on a tripod and frame a view. Make a sequence of images with different focal length lenses to explore their different angles of view. As the camera does not move, changing focal length simply produces a fixed perspective and image cropping.

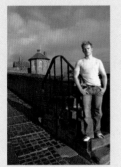

28mm

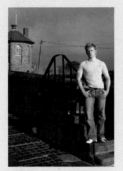

50mm

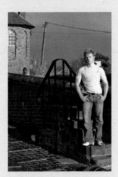

90mm

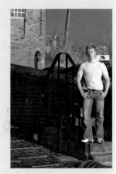

180mm

Now move the camera and with a definite subject in your image, try keeping that subject the same size in the frame by moving the camera as you change focal lengths (use the same focal lengths as before). You will need to be very close to the subject with the wide angle and some distance away for the longer focal lengths. This sequence will show dramatic changes in perspective and the relationship between subject and background.

Line can either be actual marks on the paper or a boundary suggested by shapes in the image.

Shape is an area that is defined by one of the other elements, usually line, though it can also be composed of light, texture or colour. Shape has mass.

Space is two- or three-dimensional, but most often refers to the representation of the third dimension in an image. Negative space is the absence of volume and the areas between the positive shapes.

Photographers refer to the comparative light or dark of a grey or colour as 'tone'. Artists refer to this as 'value'. In photography, changes in light levels over the surface of a three-dimensional object give the illusion of form. Form depicts volume.

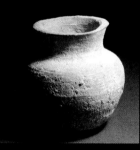

Texture is a characteristic of surface revealed by the interaction of light and the surface, for example: polished metal and glass reflect brilliantly, while velvety cloth appears dull and soft.

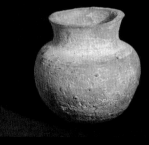

Colour can be identified as the response of the human eye and brain to different wavelengths of light – it affects our moods and emotions.

Formal elements

It is unusual to find an image that exclusively uses one of the formal elements of composition. The best images are a remarkable combination of ingredients. Looking in turn at how each of the elements can be incorporated into images will help you to understand the process of composition.

From the world of art and the compositional analysis of paintings, the formal elements are; line, shape, tone and form, texture, space and colour. The formal elements are qualities – characteristics of the subject being photographed – they are not processes. An important part of photographic composition is recognizing the formal elements and organizing them to produce a final image. The processes used to work on and combine the formal elements are often described as the 'principles of design', which – depending on your field of work (graphic arts, fine art or photography) – can be called different things. For photographers, they would include; variety, pattern, emphasis (the plane of focus within the image), symmetrical or asymmetrical balance, movement and contrast. Photographic composition may involve the manipulation of light and the subject, but more often it concerns selection and emphasis.

A photographer must be prepared to catch and hold on to those elements which give distinction to the subject or lend it atmosphere.' Bill Brandt (British photographer)

Point

In its purest photographic form, a point is the first and only place the photosensitive material changes when it reacts with light – this becomes a tiny pinpoint of light on a uniform background.

Small objects can also be points. An image of a pebble on a beach is a point rather than a small area of tone. The simple point will draw attention to itself by being the only concentration of detail in an otherwise empty image. The message conveyed by the image of a single point is usually one of overwhelming isolation.

Larger areas can have a central point that functions much in the same way as a simple point. This is the virtual point at the optical 'centre of gravity' of the area of tone – much

easier to visualize than to describe. The visual centre of an evenly toned area is easy to determine, but if there is an increase in tonal or textural density, the virtual centre point will shift towards that concentration.

The placement of the point in an image can have a big impact on the way it is read by the viewer. The direction of a shadow can determine 'ownership of space'. The point may appear closer or seem to be static if moved near to the bottom edge of the frame.

Images are rarely composed around a single point on an otherwise uniform background. Composing with a true single point is an absurdity. Expand the definition of point to mean a small area of concentrated detail, and you could say that some of the most dramatic compositions use a point to convey information about the whole.

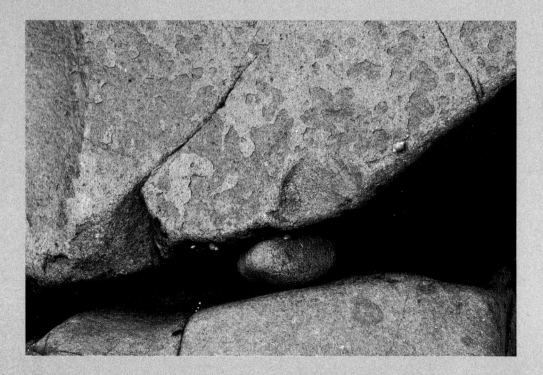

'The spot is the outcome of the first contact of the tool with the material, with the basic surface.'
Wassily Kandinsky (Russian artist)

Tate Modern Turbine Hall, London (right)

The single point of concentrated detail is revealed as the isolated form of a man in the vast exhibition space of the Tate Modern art gallery.

Photographer: Paul Stefan.

Technical summary: Canon EOS 20D Canon EF-S 17-85mm f/4-5.6 IS USM zoom, 1/60 at f/6.3, ISO 800, some local exposure control in Photoshop.

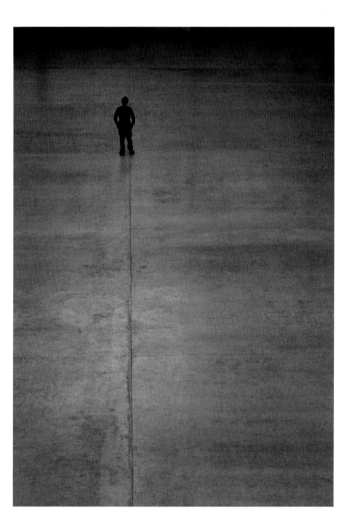

Ouch (facing opposite)

The subject is the pebble trapped in a crevice.
The greater area of simply toned rock above the pebble seems to weigh down on the pebble, which introduces a new dynamic into an otherwise sparse image.

Photographer: David Präkel.

Technical summary: Nikon D100 60mm f/2.8D AF Micro, 1/80 at f/11, ISO 200.

Point Line »

Points and optical lines

As soon as a second point is introduced into an image, a relationship is established between it and the existing point. It now becomes impossible to treat the two in isolation as individual points. They are connected by a virtual line, often called an 'optical' line. In compositional terms, virtual lines are as important as actual lines.

The quality of the optical line, its direction and angle, will be read as though it were a real line. This will have a bearing on the relationship between the two points. In fact, in some images, it may introduce an unintentional relationship. The optical line is the compositional equivalent of putting a set of weighing scales beneath any two objects – the gaze will move between the two, making comparisons. This tendency will intensify if the two points are in any way similar – in colour or texture for example. It may be preferable to exclude a second object from your composition precisely to avoid such a possibility. Cropping the

finished image or reframing the image in-camera would then be necessary.

Depending how closely associated or widely separated the two points are within the frame, the viewer is forced to make assumptions about their relationship. This will be affected by the positioning of the virtual line between them. If two points are situated at a great distance apart in either f the top corners of the frame, the image will be read in a different way than if the same two points were positioned close together in either bottom corner.

The strongest virtual line in any image is the human gaze. We all look to see where others are looking – this is a response to both our instinct for survival and to satisfy a sense of curiosity. In portraits of two people, the relationship between the two individuals is rather like that between simple points and if there is a shared gaze the implied relationship is strengthened further.

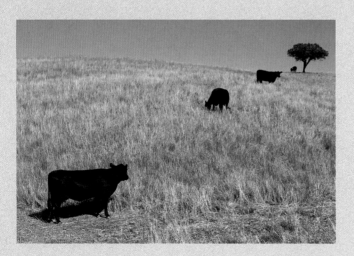

Mooh! (left)

An optical line joins the cows diagonally across the field. The tree on the horizon acts like a full stop to their 'sentence' and is given scale by the diminishing row of animals. The bulk and tone of its canopy balances the cow in the foreground.

Photographer: Jorge Coimbra.

Technical summary: Canon Powershot G3, 1/1250 at f/4.5, ISO 50.

Southern wind (right and below)

An optical line joins the centre of the heads of the two women. Their gaze also produces a set of optical lines to a point outside the frame. Their closeness and posture says there is something shared, but that they are for a moment distracted.

Photographer: Karl Fakhreddine.

Technical summary: Canon D60 Canon 35mm f/1.4 L, 1/90 at f/2.5, lit only by sunlight through windows.

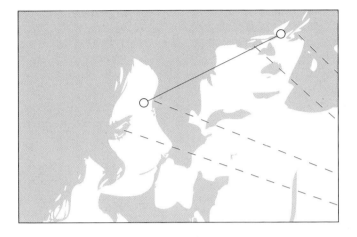

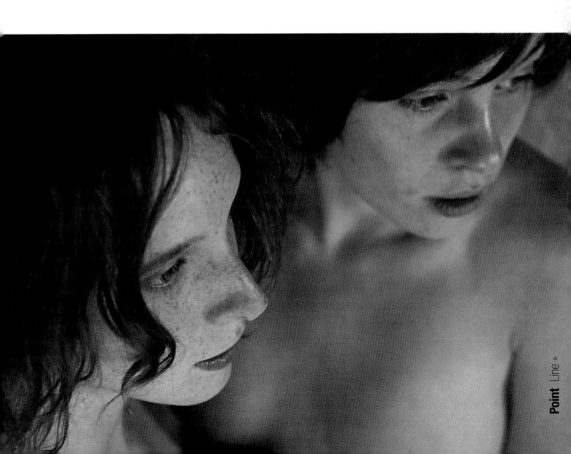

Point Line »

Groups

Just as an imaginary optical line links two points, we create shapes from simple groups of objects – psychologists describe this as 'closure'.

It is important when composing an image to treat the overall shape of a group and not just the individual items. Three stones in an image create a shape, a triangle. The composition will look either stable or unstable depending on the disposition of the triangle – whether the triangle itself appears stable or unstable. An inverted triangle is inherently unstable, while a wide-based triangle is strong. If you place four pebbles on a background they become joined in an invisible rectangle and the shape and its properties will provoke a response to the finished composition.

With groups of objects, the brain treats the shape created as a real-world object. If the shape formed by a group of objects appears unstable the image will seem vulnerable and transitory, which creates tension. If the arrangement of the components is stable, then the overall effect will be of strength and tranquillity. When composing images with a few distinct objects on a background – whether landscape or still life – consider the way objects are grouped and whether you want to use them to create an undercurrent of tension or a sense of calm.

One of the hardest effects to achieve in still life is to create a natural composition. Experimenting with a handful of disparate pebbles, you will discover that you start to create patterns when trying to arrange them in a 'natural' way. It is difficult to achieve a genuinely random, natural-looking arrangement. This shows how powerfully we search for pattern and structure. Selecting an odd number of items when photographing groups helps to avoid regularity.

Optical lines (below and facing opposite)

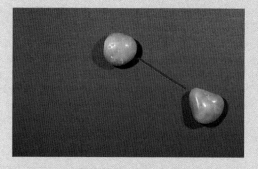

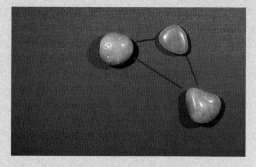

An optical line links the two individual points. Given the equivalence of the two points, they can only be treated as the end points of a line.

Introduce a third point and a shape emerges – in this case an unstable triangle.

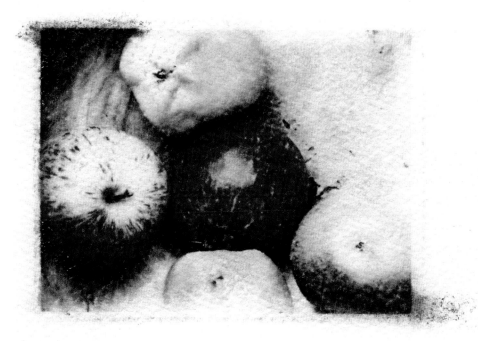

Polaroid apples (above)

A group of apples in a wooden bowl – move any one and the arrangement might collapse.

Photographer: David Präkel.

Technical summary: Polaroid Polacolor ER image transfer on Fabriano cold-pressed watercolour paper from a Kodak Elite Chrome Extra Color 100 35mm transparency.

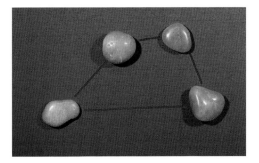

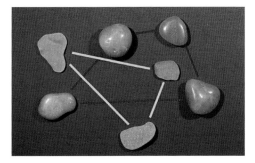

The fourth point creates a stable rectangle. Irrespective of the distance between the fourth point and the first three, the figure is not interpreted as a triangle and an isolated point. The original line has gone, although its end points have not moved.

With three more points there are two groups of points based on similar properties. The original rectangle remains, joined by an unstable triangle. A new group formation – based on similar colour or shape – will be treated as its own separate shape.

Point Line »

Line

Lines are really a mental construct. Our visual system acts to simplify the visual jumble in the world. It does this by emphasizing the edges and contours of objects while minimizing areas of constant tone in a process known as 'lateral inhibition'.

This begins to explain why we draw with lines when in nature true lines are rare and are more likely to be the visual boundary between one area of tone and another. Lines form the outlines and shapes that make up our earliest drawings on paper; only later do we learn to sketch in tone and shadow representing form. Even painters use simple construction lines in their underpainting and preparatory sketches. Drawn lines can have different qualities – strong, continuous, weak and even intermittent.

One of the most important lines in photography is the horizon. The sea/sky horizon is usually a true line and needs careful alignment in images. If the horizon is an area of water – as water is only at rest on a truly horizontal plane – it becomes important to level the camera to create a stable image that does not appear to be slipping off the print. It is particularly difficult to square up the camera faced with curving shorelines and mountain ranges – some photographers resort to using a bubble level or digital artificial horizon display.

Lines and boundaries (below)
There are often few true lines in our images (1 and 3) as many lines are really boundaries between areas of tone (2 and 4).

1 2 3 4

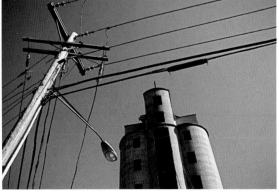

Grain tower and power lines (left)
Real lines like the condensation trails produced by jet aircraft, and overhead power and telephone lines can be successfully built into an image.

Photographer: David Präkel.

Technical summary: Canon PowerShot G9 7.4mm (30mm 35mm equivalent), 1/640, at f/4 ISO 100.

The meaning of lines

Just as we treat images of objects as stand-ins for the real thing, we treat lines in an image as though familiar, real-world forces such as gravity or the wind act upon them. There are two states of balance for straight lines; vertical lines [1] are one. They represent a balance of forces and are static. Forces are in balance to keep the line upright.

A gently curved line [2] shows the action of unequal forces bending the line over to one side – the greater the curvature, the greater the apparent force. We know the direction of the force from what we know of nature – that the line bends away from the force. The curved line is stable, but giving way to the force acting upon it.

Angled lines [3] are dynamic. They are most unstable around 45 degrees – the line appears about to fall flat at any moment.

Sinuous, S-shaped lines [4] are known as beauty or 'Serpentine' curves. Their interpretation can depend on their orientation in the frame; arranged vertically they reflect strength and dynamic balance, like muscles acting on each other. Across the frame, they are undulating like hills or rivers through a landscape or the soft curves of a reclining body. They show the action of great forces moving slowly.

Zigzag lines [5] are evidence of a disruptive force, and are interpreted variously as exciting, angry or unsettling. They represent concentrated energy.

Horizontal lines [6] are the most stable. They respond to gravity and are at rest and motionless.

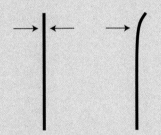

Upright line [1] Gently curved line [2] Dynamic angled line [3] 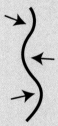 S-shaped line [4]

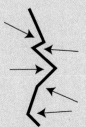

Zigzag line [5]

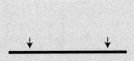

Horizontal line [6]

Diagonals

Angled lines impart some degree of movement. Diagonals are a special case. They are lines that run roughly from one corner of an image to another. They give the feeling that not only is the line displaced but we have caught it at the moment it is displaced; like a cartoon character running off a cliff, we know the inevitable outcome. This creates a feeling of expectation, movement and tension in what would otherwise be a static image. They need not be actual lines, as points in diagonal arrangements appear to move down the optical line that joins them.

Diagonals appear in images in one of two ways. Lines that are diagonal in the real world can be photographed in their true orientation. Alternatively, lines that are horizontal or vertical in the real world can be canted over to the diagonal. Tipping an image over in the frame has become photographic shorthand for energy and dynamism, or sometimes disorientation. Just cropping an image of a stationary vehicle on the slant will make it appear to be moving. In Western culture, our eyes are accustomed to scanning a page of text from top left to bottom right. We treat empty rectangles in much the same way. Diagonal lines that run with the gaze reflect a sense of order, but do not have the same impact as those that run counter to our gaze. Diagonals that run from bottom left of the image to top right are considered more dynamic and give a greater sense of movement.

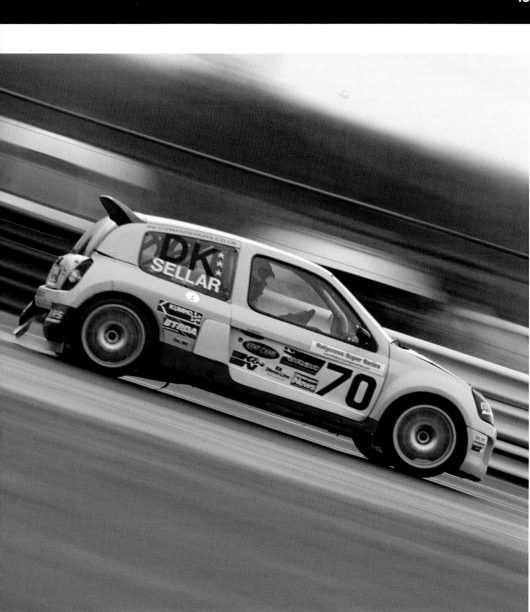

Grand Prix, British Rallycross (above)

Although it is usual to leave some space in front of a moving object, Elsworth places the subject at the bottom of the slope and as close to the frame edge as possible to accentuate speed. Careful pre-focus and panning with the autofocus off captures the subject sharp, even at slow shutter speed.

Photographer: David Elsworth.

Technical summary: Nikon D100 Sigma 70-300mm f/4-5.6 DG zoom, 1/20 at f/8, ISO 400.

« Point **Line** Shape »

Curves

A simple curve can have the same dynamic effect as a diagonal line but it somehow calms and slows down the action. Because of their close association with the curves of the human body and with gently rolling hills and valleys, we connect curved lines with beauty and the sensual.

The 'line of beauty', about which the artist William Hogarth wrote at length, is a double curve or flat S shape (a 'compound' as opposed to 'simple' curve). The ideal is said to be the curve where the lower back joins the upper buttocks – which is much the same in a man or woman. Aligned vertically, this compound curve looks perfectly balanced. Gravity runs through it but the curve seems to resist the force. The beauty curve is also referred to as a 'cyma' curve (from the Greek, meaning 'wave'). Sensuous curves are produced where water wears down rock with the action of the waves. Photographers have found water-worn rock a rich source of images that are sympathetic with the human form. There is a satisfying harmony and stillness in these curves.

When the S shape lies in the perspective plane of the image and is foreshortened – in, for example, an image of a meandering river it suggests natural, unhurried progression. It lends a feeling of timelessness without the image appearing to be static. A real or absolute line is not needed, only the suggestion of the curve by careful placement of points of interest.

Two beauty curves together can suggest pulchritude, kissing lips or, if reflected back to back, the upward flickering of the flame.

Eleanor 1947 (facing opposite)
One of Callahan's series of nude images of his wife, in which the female form is brilliantly reduced to the graceful simplicity of a curved and branching line. The crop around the subject abstracts it slightly, forcing the viewer to question what it might be.

Photographer: Harry Callahan.

Technical summary: None available.

Leading lines

The concept of 'leading lines' is one of the oldest in photographic composition. It is also one of the hardest to discredit, despite being challenged by scientific evidence.

Leading lines, which are meant to entice the eye towards the real subject, are a photographic myth. As long ago as 1973, Andreas Feininger, one of the best photographic writers of his day, wrote: 'The entire theory of leading lines is a fallacy.' Yet, the idea is still presented as 'fact' in photographic magazine articles and on websites today. Research studies, using miniature cameras to record eye movements, show that our eyes do not follow lines, real or otherwise, in images. In fact, our gaze is more attracted to angles than to straight lines. Viewers often 'enter' the picture at small areas of high contrast (potentially significant features) looking straight at the part of the picture that first 'catches their eye'.

When we look at a picture, the order in which we scan the different elements varies considerably – as does the time we spend scanning for and looking at each element. Experiments on human eye movement show that viewers spend most of their time looking at parts of an image that have the most detail, contrast or curvature. The viewer may see other things in your images than your subject. He or she may be interested in entirely different aspects of the subject than what you intended to show.

Presented with accompanying texts or captions, the viewer can be predisposed to scan images in a particular way. (What a viewer also brings in terms of personal experience or cultural learning will have a major impact on what they 'see' in a picture.) The viewer treats portraits in much the same way as another human face, spending time looking into and around the eyes particularly as there is no fear of 'returned gaze' with a photographic portrait. The painting opposite, titled 'They did not expect him' by Ilya Repin, a Russian naturalist painter, was used in an experiment by the psychologist Alfred Yarbus to determine the patterns of just this kind of 'seeing'.

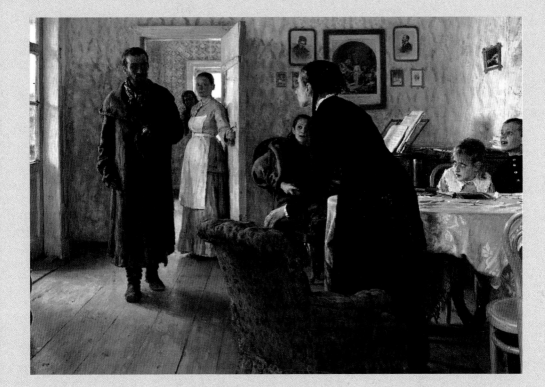

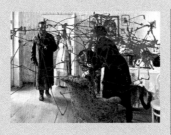

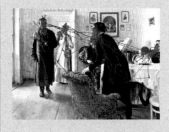

1

This scan pattern shows how a viewer looked at this picture, without any specific instruction. There is no evidence that viewers use the strong perspective lines of the floorboards as 'leading lines'.

2

This scan pattern shows how a viewer looked at the picture when asked to judge the wealth and standing of the family depicted in the painting.

3

This shows the eye-movement pattern produced when a viewer was asked to estimate the ages of the characters in the painting.

« Point **Line** Shape »

Shape

Shape is usually defined by one of the other formal elements, such as line. Shapes are even described as being delineated, but shape can also be composed of an area of even or gradually changing tone. A pool of light, a patch of texture or splash of colour all present as shape. What has already been said about curves and zigzag lines applies equally to curved and jagged shapes.

As in the real world, certain shapes seem stable in one orientation (usually biggest and flattest side down). Tension can be produced in an image by introducing unstable shapes. As with literal and optical lines, there can be literal and virtual shapes in our images. In the section on groups, page 40, we saw how shapes are created by a number of points enclosing an otherwise plain area of background. Our active visual-processing system loves the challenge of ambiguity and tries to work out the puzzle by looking for recognizable shapes.

Artists treat shapes as being either geometric or natural shapes. Abstract shapes are generally natural forms that have been simplified in some way. Many photographers have studied natural organic shapes to find the underlying geometry.

A common device is to photograph an object that has the shape of another – a cloud that looks like a face, for example. These images have the same attraction as optical illusions based on the reversal of a human face or figure – the fascination stems from not being able to see both forms of the image at once.

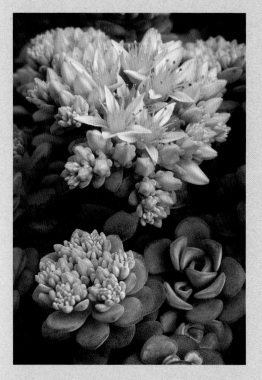

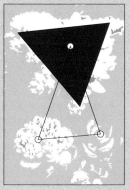

A stable and unstable triangle arrangement.

Succulent triangle (left)

Three optical centres produce a stable triangular arrangement, while the inverted triangle of colour above introduces an unstable dynamic into this close-up photograph of three stages of flower growth.

Photographer: David Präkel.

Technical summary: Nikon D100 60mm f/2.8D AF Micro, 1/10 at f/32, low, summer evening light, ISO 200.

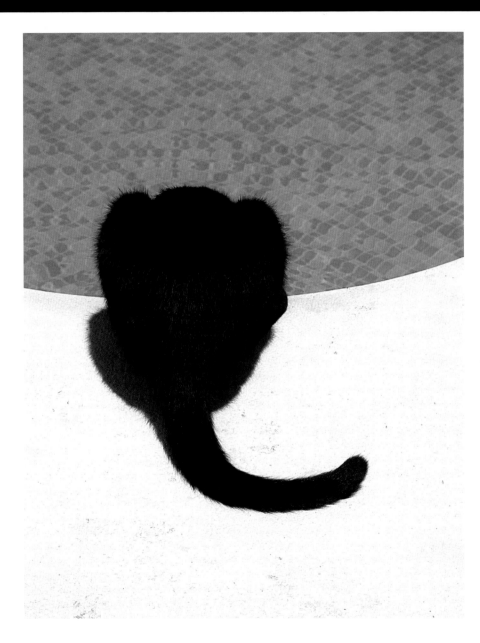

Pose (above)

The picture has 'incident'. Once we make out the simplified shape of the black cat, we know that a cat in this posture is just poised to spring.

Photographer: Jorge Coimbra.

Technical summary: Canon Powershot G3, 1/800 at f8, ISO 50.

Dominance of size and tone

In any image, two areas of roughly the same size and tone will appear to be in balance. The balance will tip in favour of either a larger area, an area with greater density of information (more detail) or one that is markedly darker or lighter than the rest of the picture.

Painters refer to this quality as 'attraction'. Some elements will attract more attention than others. Shape, lines, tone, form, pattern density and complexity, colour – all play a part in the balancing act, which is difficult to quantify, but easier to identify in well-composed images.

Position also plays an important role. Given the same two elements, the one nearest the edge will be treated as having greater 'attraction'. Every part of the image has some degree of attraction and even an 'empty' background will have some aspect of tonal gradation or even 'suggestion' of what is not or what could be there. Individual points – especially similarly sized or toned points – will be associated by the viewer and will be assessed, from the point of view of balance, as a single entity.

The eye naturally seeks balance in an image and this can be either static or dynamic. Static balance is found in purely symmetrical images with their equal elements placed on either side of a central line or pivot – these images, their strengths and weaknesses, are covered later in the book (see page 108). Dynamic balance is achieved when items with unequal attraction are given some equivalence. This can be done by increasing the attraction of one by putting it near an important locus within the frame (the centre of interest 'hotspots') or near to the frame's edge.

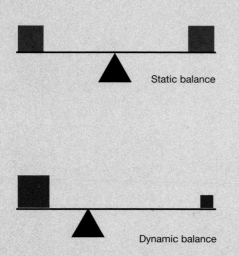

Static balance

Dynamic balance

Static and dynamic balance (left)
When formal elements are present in equal quality/quantity around a central line – the 'pivot point' or 'fulcrum' – the picture is described as being in 'static balance'. It may be pleasing to look at, but there will be no drama.

An image can still be in balance when formal elements are present in unequal quantities/qualities if the balance point of the picture is shifted. Here, a small, dense object balances a larger, lighter object. This is known as 'dynamic balance' and it lends drama and tension to an image.

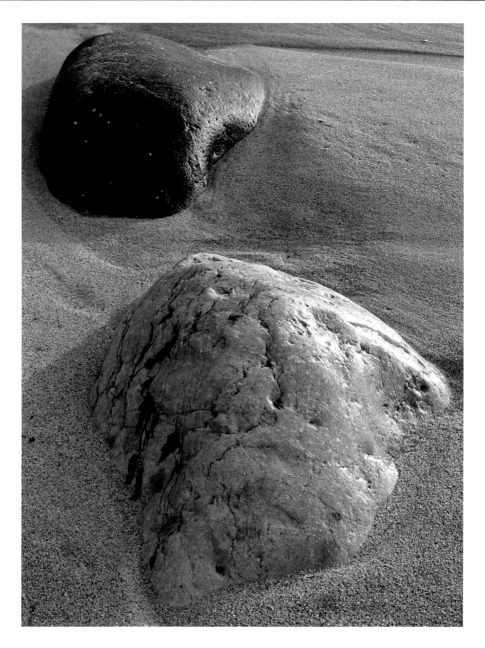

Balance (above)

Dynamic balance applied to the foreground and background of an image. Balance is not to be judged across a horizontal line in an image, but in the planes of the image itself. A darker, small object in the distance will balance a lighter, larger object in the foreground.

Photographer: Jorge Coimbra.

Technical summary: Canon PowerShot G3, 1/250 at f/4, ISO 50.

« Line **Shape** Form »

Negative shapes

If people are presented with a completely homogeneous field of view they become disoriented – pilots and skiers sometimes report this in 'white out' weather conditions. Our visual system needs something on which to fix.

Our visual world consists of numerous instances of subjects seen against their backgrounds. We choose the subject depending on our motivation. What a photographer would refer to as 'subject' and 'background' is what a psychologist would call 'figure' and 'ground'. Artists would refer to the same idea as 'positive' and 'negative' shape. If the subject of the photograph is the positive shape, then the background is the negative shape. The optical illusion of figure and ground immediately produces tension. This is because the brain, unable to hold on to both negative and positive shapes, can't decide which is the most important. Choice of viewpoint can distinguish between or emphasize the relationship between subject and background. When taking a picture, positive and negative shapes can be enhanced by lighting to produce wide tonal separation between the subject and background. High-contrast film or custom contrast curves on a digital camera can be used to enhance the difference. At printing stage, high-contrast photographic paper can reduce the shading and fine textures that contribute to the appearance of form. The manipulation of contrast and threshold gives much the same control with digital images.

Ambiguous (left)

Figure/ground reversal in a real photograph – it is a hand, but are the fingers light or dark?

Photographer: David Präkel.

Technical summary: Nikon D100 Nikon, 70–300mm zoom, 1/125 at f4, ISO 200, deliberately defocused.

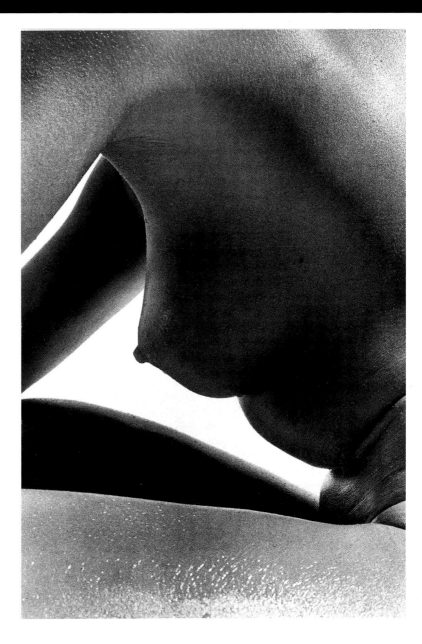

Bronze Mary Jane (above)

Strong negative spaces – here between the arms, torso and legs – begin a process of abstraction and take on an equivalent importance to the tonal areas of the image. Tension is created as the negative spaces are not quite closed.

Photographer: Ralph Gibson.

Technical summary: None available.

« Line **Shape** Form »

Form

A shape, however it is defined, is still a two-dimensional object in an image. It covers an area and is described as having 'mass'. What makes a shape take on form is the introduction of shading within its boundaries. Form is the representation of the third dimension in the two dimensions of the flat image. Once there is 'volume' in an image, we begin to react to the image with some emotion. The fullness of an earthenware jug, even the gleaming painted curves of a car spark an emotional reaction in the viewer.

Tonal gradation

We understand how light falls on three-dimensional objects from observation. We process the information from highlights and shadows to create a mental map of an object, which enables us to grasp it in our hand rather than putting our hand through the shape. The richer the information the photographer captures about the way the light falls on an object, the more realistic the representation of the object will be to the viewer. The viewer also takes some cue as to the emotional mood of a picture by the positioning of the main light. The higher the highlight on an object, the higher the 'sun' is in the sky. Conversely, low-angle lighting will be interpreted as 'evening' and will evoke tranquillity.

Beach forms (facing opposite)

Astute photographic observations of form. Shadows and highlight play an important role in creating the appearance of a sensuous three-dimensional world, enhanced by the colours and texture. Such close observation triggers a response to treat these geological formations as if they were flesh and blood.

Photographer: Stephen Coll.

Technical summary: 1954 Rolleicord 75mm Xenar f/3.5 Ektachrome 400 and 1960 Bronica S2a with Nikkor-P 75mm, f/2.8, Fuji Provia 400F.

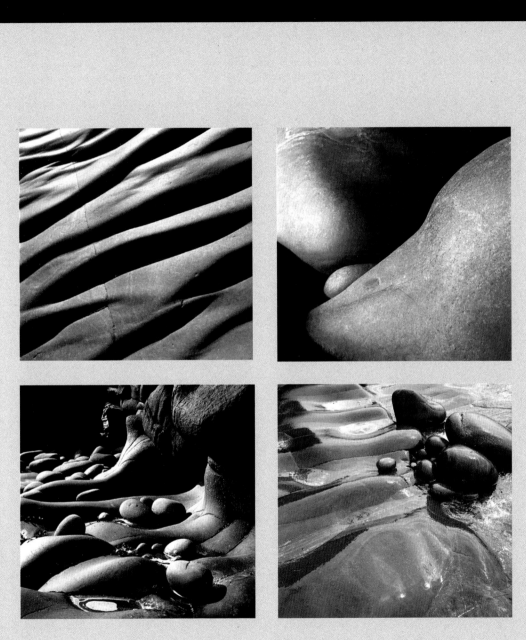

« Shape **Form** Texture »

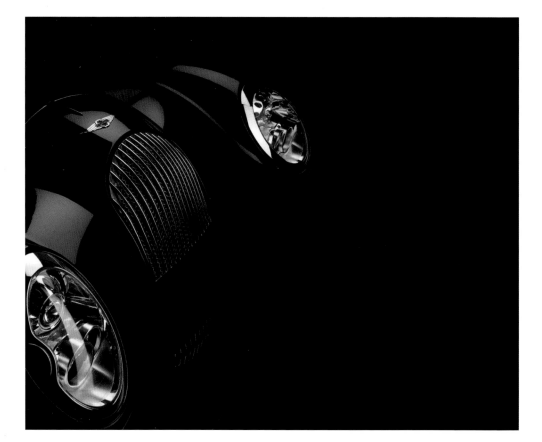

Shape plus tone

Form is simply shape plus tone. The quality of form is down to the subtlety with which the photographic medium portrays tone. Information about tone is in the density of silver grains in film or in a digital number code. Fine-grain film is a guarantor of subtle tonal information and the bigger the negative area, the better. This explains why the 5 x 4in negative and view camera are still favourites with many flower or figure photographers where capturing subtlety of tone is key.

With the digital medium it is not quite as simple as more pixels means smoother tonality. The quality of digital image processing in-camera has as much to do with the quality of tonal information as raw pixel count. The physical size of the pixels on the digital sensor and its inherent noise also play a part in how clean the image appears.

Digital post-processing can lose tonal information, especially if information has to be made up (interpolated) by the computer when levels or curves are coarsely adjusted – the existing tonal information is stretched to cover a wider range of tones, and banding (posterization) can occur that reduces the smoothness and subtlety of the tonal range. The average human eye can see more than 65, but probably fewer than 100 different shades of grey. Digital systems would seem safe with 256 levels of grey, or 8-bit, but it is easy to produce visible banding when making image adjustments. Many photographers now choose 16-bit grey, which offers a greater safety margin for manipulations.

Morgan (facing opposite)

Light and shadow are used to reveal the strong sculptural forms of this timeless aluminium-bodied Morgan Aero 8 sports car.

Photographer: Tim Wallace.

Technical summary: Nikon D3S 28–70mm f/2.8 AF-S IF-ED Zoom-Nikkor at 55mm, 1/250 at f/13.

Overcoming the limitations of 2D

Many of the art movements of the twentieth century struggled with what were considered by many to be the limitations of realist art. The cubists challenged the notion that art should reflect nature.

They turned their collective back on the traditional depiction of perspective and instead attempted to simplify form into simple geometric solids (the 'cube' of cubism) using multiple viewpoints in single images. Artists such as Picasso and Braque influenced Alfred Stieglitz and his circle of photographers in America. Conversely, Vorticist paintings looked like superimposed photographs manipulated to form swirling, moving forms in the static, flat world of the canvas.

In the early 1970s, the Yorkshire-born artist David Hockney experimented with Polaroid instant cameras to produce explorations of reverse perspective and made reference to Picasso's cubist paintings. Hockney tried to break through the two-dimensional bounds of the photograph by capturing a series of images taken around an object. He experimented with 'reverse' perspective, creating striking portraits, which looked as though the skin had been unwrapped from the subject.

Early on, Hockney created montages of component images in a structured grid and later in a freer style. He called these images 'joiners'. Intriguingly, as he shot the images, he was also recording the passing of time. His joiners are a combination of images of the same subject taken from different viewpoints at different times.

Digital cameras are uniquely convenient for shooting sequences of images that explore the three-dimensional nature of an object. Imaging software makes it easy to create a blank digital canvas and to drop in the various images to create a 'joiner'.

Ian washing his hair, London, January, 1983 (facing opposite)
This 'joiner' expands both space and time to create a complex narrative within the image.
Photographer: David Hockney.
Technical summary: None available.

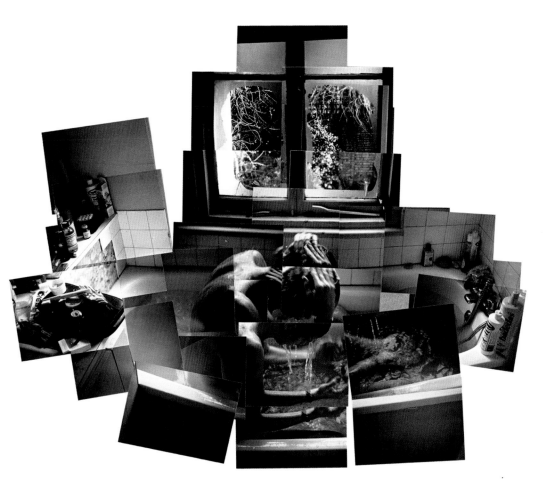

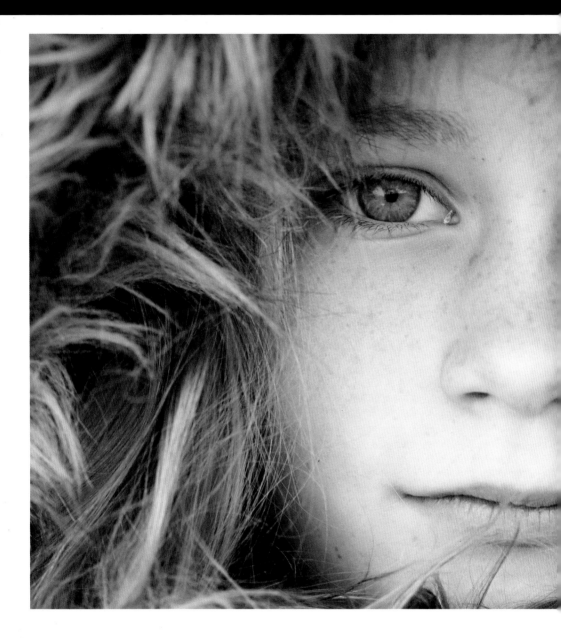

Emilie (above)

Texture need not mean rough wood and rock. Diffuse frontal light and a shallow depth of field (critically focused on the eyes) flatter the smooth skin textures of this young sitter and the soft fur of the hood.

Photographer: Nina Indset Andersen.

Technical summary: No camera details. White balance adjusted in converting the RAW digital file to give a colder (bluer) light quality.

Texture

Sight and touch are closely related senses. Because of this strong connection, developed in our infancy, the visual representation of texture can generate a strong emotional response through association or memory. In many viewers, the high-contrast texture of reptile skin will evoke quite a different reaction from softly lit wool. The photographer can exaggerate texture to evoke emotion or can choose lighting conditions that reduce the appearance of texture when it is not wanted.

When we talk about texture, we often mean the surface area of objects, such as rock or wood, but texture in an image can mean much larger or more expansive features of landscape, for example the furrows of a ploughed field seen from a distance. The differences between textures help the viewer to appreciate depth and perspective in an image. Just as the archaeological photographer waits for slanting light to reveal the shadow of a long-buried village, the landscape photographer waits for the sun to illuminate the textures of sand dunes, rocks, and cultivated fields.

In portraiture, care must be taken with the angle of light so as not to unduly emphasize skin texture if it is not appropriate to the image. High-contrast side lighting can add years to the appearance of skin. Softening the light and angling it directly onto the subject reduces the effect.

Angle and quality of light
When light falls across the surface of an object at an angle it reveals its texture – the shallower the angle, the more prominent the texture. Direct lighting illuminates the tiny peaks and troughs of a textured surface evenly, which reduces the appearance of texture. Side or 'raking' light casts deep shadows that enhance the texture of an object. If the texture has a 'grain' – wood or skin, for example – the lighting should always be angled at right angles to the run of the grain to fully reveal the texture.

The quality of light also plays a part. The important aspect is not the colour or direction of the light but whether it is diffuse or focused, 'omni-directional' (spreading in all directions) or from a single source. Some light sources cast hard shadows, while others create softer shadows – each reveals the texture of a surface differently. Soft boxes and available light through a window, for example, produce 'flattering' light. This 'soft' lighting is frequently used in portrait, glamour and fashion photography where the skin texture is important. Conversely, a spotlight throws hard light on a subject, producing hard-edged shadows, which are useful for adding character to a face.

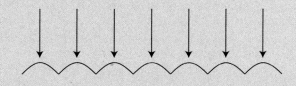

Light hits the surface at right angles, illuminating peaks and valleys evenly.

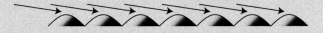

Light hits the surface at a shallow angle so that each peak casts a shadow in the next valley – creating micro contrast (texture).

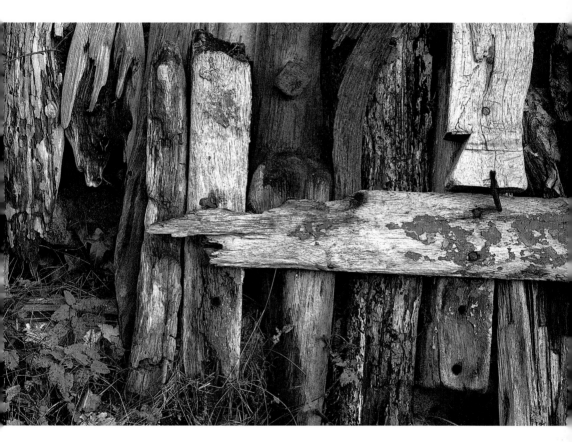

Driftwood (above)

Low evening light picks out the wood grain and worn paint in this fence made from driftwood in Kippford, Scotland.

Photographer: David Präkel.

Technical summary: Nikon D100 with 60mm f/2.8D AF Micro, 1/90 at f/4.8, ISO 200.

« Form **Texture** Pattern»

Grain and noise

Beyond the texture of the subject and of lighting, the medium can contain its own texture. Black-and-white film is composed of clusters of silver halide crystals and colour film is composed of tiny clouds of dye.

Film that is more sensitive to light is composed of coarser grains. Grain lends structure and many black-and-white photographers consider that grain adds value to an image.

Digital has its 'grain' too – this is called noise. When a digital camera takes long exposures in low light, the background noise of the sensor itself can be nearly as big as the signal (the picture) that is being recorded. The sensors in digital cameras are analogue devices, which sample the image, divide it up into pixels and measure the power of the red, green and blue components of each of

these picture elements – this information only becomes digital after it leaves the sensor in an analogue-to-digital converter. The sensor's inherent background noise can break up the image with pixel values that are 'out of place' – hence, visual 'noise'. Digital photographers more often consider noise to be detrimental to the quality of an image. They employ noise-reduction software to reduce the effects.

However, noise can enhance an image. Older professional digital cameras have high-sensitivity settings that produce lots of 'chroma', or colour noise, creating an effect similar to the coloured grain of high-speed colour film. Digital camera manufacturers are becoming increasingly smart at lowering noise in their camera designs, which means digital noise may now have to be added to an image in post-production using image-editing software.

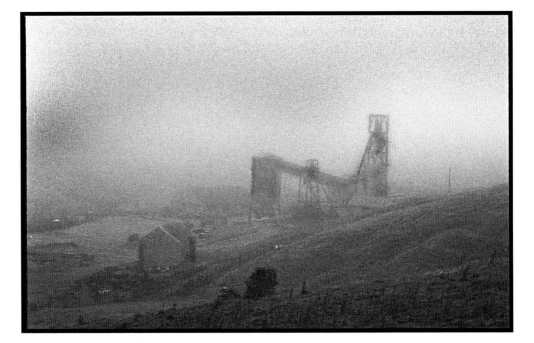

Pictish man (right)

This small fragment of a Pictish carving of a saint lay in the dark corner of a museum cabinet. High digital chroma (colour) noise was a bonus for this subject.

Photographer: David Präkel.

Technical summary: Nikon D100 60mm f/2.8D AF Micro, 1/60 at f/4, ISO 6400.

Grove Rake mine (facing opposite)

The film grain adds to the exceptionally heavy rain in this image of the remains of the last working fluorite mine in the high North Pennines, UK.

Photographer: David Präkel.

Technical summary: Leica R8 35-70mm Vario-Elmar-R, f/4 zoom exposure not recorded, Kodak TMax 3200 digital brown tone.

« Form **Texture** Pattern»

ISO 100214 (above)
Rogge's human patterns combine repetition with individuality, posing deeper questions about identity, the crowd and the person.

Photographer: Claudia Rogge.

Technical summary: Canon EOS 5D Mark II, with Bowens flash. Single photos are combined on the computer to create the final image.

Pattern

Humans are fascinated by pattern. When we look at anything, the receptor cells in the retina react specifically to certain lines, angles, colour and movement under the organizing control of the visual cortex in our brains. The appeal of visual puzzles and the eye-catching quality of interlocking patterns demonstrates this. Our brains are 'programmed' to compare the elements of pattern and to look for differences.

Pictures containing patterns must feature something more than simple repetition. It can be easily over-done and becomes a compositional cliché. The challenge for the photographer is to capture the rhythms and variations of alternating pattern in an image, while also saying something about the subject being photographed. Perversely, what grabs the viewer's attention is when expectations are not confirmed – when the pattern breaks, for example.

Pattern can even be used to reveal form. Light coming through repeating structures, such as fences or windowpanes, creates fascinating shapes as each repeated block of the pattern falls onto and wraps around the solid form. A very fine repeating pattern will look like a texture, while patterns that reduce in size appear to recede in space.

The urban landscape is full of geometric, repeating patterns, while nature offers a more random arrangement of quite complex patterns that can be harder to interpret.

Tone

Increased contrast in an image simplifies shape and emphasizes strong textures. Lower contrast will soften tone, reduce the appearance of texture and can change the mood of an image. Contrast can be altered for artistic reasons – this is subjective or interpretative printing as opposed to objective or technically correct printing.

Tone refers to the full gamut of greys – all the shades from solid black to paper white. A subject with a full range of tones has normal contrast. In black-and-white photography, the degree of contrast in the printing paper is selected to match the contrast in the negative to produce a print with a full scale of tones. Variable contrast papers, which alter contrast under different combinations of yellow and magenta light, make this easy in the darkroom. A low-contrast print is composed largely of light greys and dark greys. The degree to which a low-contrast image is successful depends very much on the subject of the image. Low-contrast images evoke tranquillity. High-contrast images contain more extremes between black and white with very little mid-tone information. They are attention-grabbers and their graphic nature can sometimes enhance the compositional structure of an image.

Using image-editing software, contrast can be adjusted in Adobe Photoshop using the contrast slider in the Brightness and Contrast adjustment dialog box, although this is often not the best way to achieve the effect. The contrast slider can push pixel values through the black and white limits, producing shadows with little detail or blown-out highlights. These effects are called 'clipping'. The Level or Curves adjustment is better. With Levels or Curves, the black and white points of the image are pinned and the contrast curve can be adjusted either through multiple points (Curves) or by moving a central point (the grey or gamma point slider in Levels). The Greek letter gamma was originally the value used to describe the slope of the contrast curve in film.

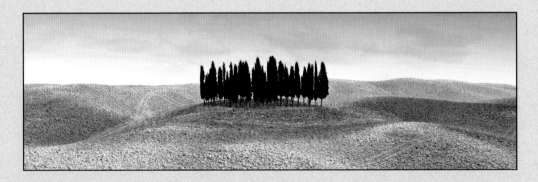

Toscano (above)

The high-contrast approach helps emphasize the graphic qualities in this symmetrical panoramic composition of a Tuscan landscape.

Photographer: Ilona Wellman.

Technical summary: Four frames taken with Nikon Coolpix 5700, 1/500 at f/5.1 and merged in Photoshop.

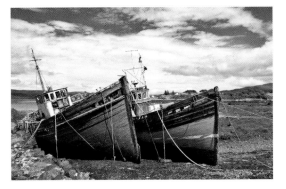

High contrast

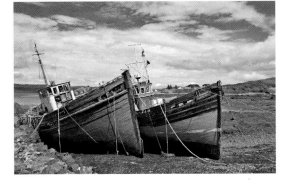

Normal contrast

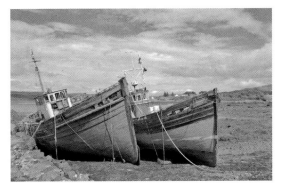

Low contrast

'The artist must feel free to select his rendering of tonality as he is to express any other aspect of the subject.' Ansel Adams (American landscape photographer)

« Pattern **Tone** Colour »

A correctly exposed high-key image of largely white objects. The digital histogram shows few mid-grey tones and a predominance of light greys.

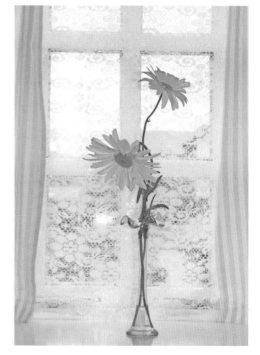

Key

The overall tone of a photograph is described as 'key', from the key light, which is the main light setting the mood of a portrait. High-key refers to an image that is predominantly composed of lighter tones, while an image composed largely of darker tones is said to be 'low-key'.

High-key

A true high-key image will contain a full range of tones from black to white, but with a preponderance of lighter tones. This is not the same as an overexposed image, which will have no dark tones whatever. In high-key portraits, pupils and shadows in the nostrils or ear tend to be the only black parts in an otherwise light-toned image.

Great care is needed in lighting for high-key, as it is easy to overexpose the image. This is much more of a problem with digital cameras. The photographer must decide whether a tone is required in the 'whites' or whether they will be 'blown out', which means the printing paper will show through in these areas. Studio high-key invariably uses white backgrounds or a lit softbox as a background to create the effect. The same applies for metering low-key images.

Window sill (above)

Colour can be given high-key treatment as effectively as black-and-white. Flooded with natural backlight in a well-lit window, these flowers were perfect for a high-key approach. On-camera flash was used to lift the blooms with compensation of -1 stop to balance the flash component of the image. The camera histogram display was used to avoid blown-out highlights.

Photographer: David Präkel.

Technical summary: Nikon D100 60mm f/2.8D AF Micro, 1/180 at f/8, background slightly desaturated.

Low-key

True low-key images retain a full range of tones from black to pure white, but they are composed mainly of darker tones. Think of them as predominantly dark images with a small area of high contrast.

Low-key images have a sombre, moody feel and can be produced in two ways. A composition containing only dark elements when correctly exposed will produce a low-key image. Alternatively, a scene with a normal range of tones can be darkened right down and lit selectively. Underexposing a normal scene will not produce a low-key image, as the image will have no highlight information.

Holding on to shadow detail is difficult with low-key images. Don't use a reflected light meter reading unless you meter from a standard grey card or use exposure compensation; the image will not be dark enough. An incident light meter that measures the light falling on the subject will give an accurate exposure for low-key as well as high-key images.

A correctly exposed low-key image of black objects. The digital histogram, left, correctly displays no information above mid-grey and a predominance of dark greys and shadows.

Portrait of Spring Hurlburt (left)

This low-key studio portrait of a woman in veil and hat evokes a sense of sadness and mourning. The picture was taken of the subject after her father's death and she contributed the image to the photographer's project 'Different Hats'. The left side of the subject's face bears the lightest tones and shows good modelling from the key light – the natural skin tones are darkened by the veil.

Photographer: Jim Allen.

Technical summary: Sinar P 5 x 4 large-format camera, 210mm Nikkor f/5.6, scanned from Polaroid Type 54.

« Pattern **Tone** Colour »

Colour

Photographers deal with light. Without light, there are no colours. Our eyes, computer screens and camera sensors all work with the red, green and blue components of white light. Red, green and blue are called 'additive primaries'. 'Primary' because these are the colours from which all other colours can be made, 'additive' because when added equally together they make pure white light. Taking away each of the additive primaries in turn from white light creates cyan (white less red), magenta (white less green) and yellow (white less blue) light. These are known as the 'subtractive primaries'. Added together they make black; in printing all other colours can be made from the subtractive primary colours.

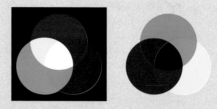

RGB values
Computer simulation of colour is achieved by mixing red, green and blue light on an integer scale from 0 to 255. With 256 levels (8-bits) per channel, this model represents 16.7 million colours. A colour can be described by the three values of its RGB components: for example, a warm red might be red 218, green 63, blue 53.

Colour wheel
Photographers find it useful to represent colour on a wheel. Imagine an equal-sided triangle with each of the three points labelled red, green, blue (RGB) in any order. Now imagine a second triangle upside-down on top of the first, with each of the three points labelled with the subtractive primary colours: yellow as a mix of red and green, cyan as a mix of green and blue and magenta as a mix of red and blue. Imagine each spot of pure colour blending into the next to create the colour wheel.

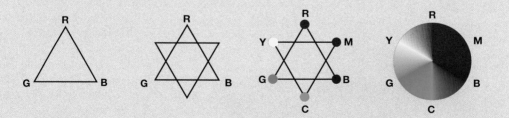

The colour wheel can be used to work out colour corrections (adding the diametrically opposite colour to correct an unwanted colour cast). It is also useful when working out which colour filter is needed with black-and-white film to darken and lighten the appearance of certain colours in the finished print. Using a yellow, orange or red filter darkens blue/cyan skies while a yellow-green filter lightens yellow-green foliage. The colour wheel rule for filters is that opposite colours darken while similar colours lighten.

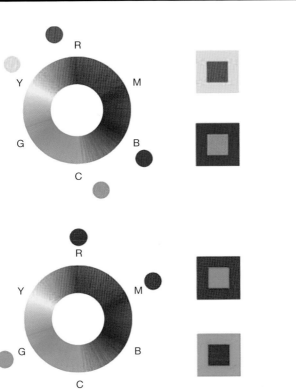

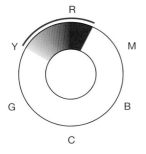 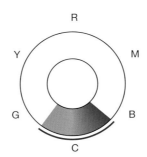

Harmony and discord (left)
In aesthetic terms, colours adjacent to each other on the wheel are said to be in 'harmony', whereas colours opposite to each other are described as being in 'discord'. A blue flower stands out from a yellow background or a red sailboat stands out on a sea reflecting a blue sky. Colour contrast comes from different colours of the same brightness or the same saturation. Hues far apart on the colour wheel show a great contrast, but those diametrically opposite show the greatest contrast.

'Warm' colours revolve around yellow and 'cold' colours around blue.

Colour associations

Colours also have psychological associations (although this is culturally dependent). In Western culture, red is a signal colour associated with warning, action, fire and anger. White is associated with purity – but in the East it is connected to death and mourning, for example.

Colour temperature

If a block of iron is heated it passes through all the colours of red, orange and yellow, from dull red to white hot, at which point the iron burns (oxidizes). The real temperature of the object can even be estimated from its colour. Colour temperature relates back to this concept as all our light sources are radiating energy. Colour temperature is measured in Kelvin (K).

Light source	Colour temperature	Colour
Candles and oil lamps	1800–2000K	Rich yellow-orange
Household light bulbs	2800–3000K	Yellow
Sunrise or sunset	4000–4500K	Rich golden
Morning/evening sunshine	5000K	Yellow-white
Noon daylight/electronic flash	5500–6500K	White
Hazy sky	6000–7000K	Blue-white
Heavily overcast sky	7500K	Quite blue
Reflections from clear blue sky in shade	16000K	Very blue

The quality (temperature) of the illuminating light needs to be considered when you take colour pictures. The time of day has a big effect on the colour of light. Reflected light takes the colour of the surface from which it reflects.

For film, colour temperature can be adjusted by choosing from a range of blue- and amber-coloured filters over the lens. These filters do not have to be used to correct light for pure white, but can be used to artificially warm up or cool down an image. On digital cameras, colour temperature is more easily adjusted either on fixed settings through the White Balance menu or by entering a colour temperature in Kelvin. The Daylight setting for White Balance on a digital camera or 'daylight' film interprets 'daylight' as the sun in a blue sky, one-third filled with fluffy, white clouds (the sun shining in a clear, blue sky is actually too blue). RAW capture lets you adjust white balance after the image is taken.

Achromatic colours

Some of the most important colours in colour photography are the so-called achromatic or 'without colour' colours – black, grey and white. These act as a foil for the colours of your composition. Any colour cast present in the scene will show first in these colours. White becomes grey as brightness is changed. A yellow cast is warm, while a shift to blue is cold. (See also the section on warmtone and cooltone, page 84.)

Spot colour

Small patches of very intense colour can be used to dramatic effect.

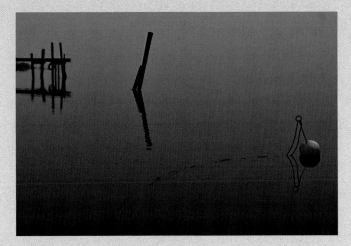

Red in fog (left)

The single spot of red colour of the buoy floating in a lake reflecting grey (achromatic background) boosts the graphic impact of the composition.

Photographer:
Trine Sirnes Thorne.

Technical summary: Nikon Coolpix 880.

Chromatic colours

The strongest, most intense, or highly saturated colours can confuse and dazzle the viewer or – more simply – attract their attention.

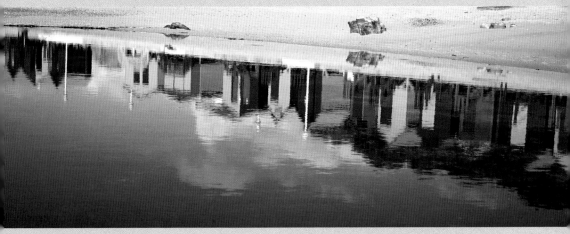

St James beach huts (above)

A long row of beach huts painted in primary colours near Cape Town, South Africa. The reflection of the strand and water's edge add a twist to this colourful panorama.

Photographer: John Barclay.

Technical summary: Hasselblad XPan 90mm lens, 1/60 at f/8, Fuji Velvia 50.

Saturation

Saturation is a technical term meaning strength of colour. Neutral grey has no colour saturation. A bowl of fruit with ripe red apples and yellow bananas features highly saturated colours. A meadow in morning haze will show only soft, pastel (unsaturated) colours. In compositional terms, colour saturation communicates an intensity of mood or feeling and acts like a volume control on any basic colour association.

In low light, only the strongest colours preserve their intensity. In very bright light (glare) the colours appear washed out. In strongly backlit scenes colours can contrast with deep, black shadows, while flat, bright light creates the most saturated colours.

To desaturate an image in-camera, use a diffusion or fog filter. Even something as simple as a plastic bag or nylon gauze pulled over the lens produces a degree of desaturation. It is harder to increase saturation without using an 'extra colour' negative and transparency film. Digital cameras may provide an option to choose a saturated or desaturated image, though it is often better to achieve the effect later using computer software.

Colour-enhancing filters 'pop', or boost, one wavelength of light – a 'redhancer', for example, will pop reds. These filters, made of rare earth glass, are often used to enrich the mood of garden images taken in autumn and can be used with digital or with film cameras.

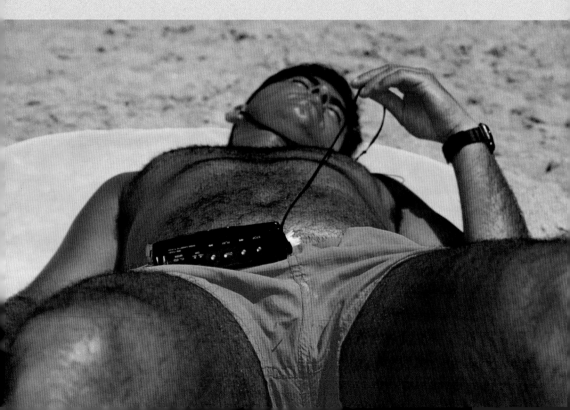

Computer modelling

Computers give digital photographers control over the separate colour and luminance components of an image. One method is via the HSL colour model. This describes colour in terms of its hue (colour), saturation (strength) and lightness (whiteness or the degree to which it appears to reflect light). This model enables digital photographers to make changes in composition after taking the photograph by altering the colour of certain elements, and increasing or decreasing the saturation of colours.

Hue/Saturation	
Edit:: Master	OK
Hue: 0	Cancel
Saturation: 0	Load...
Lightness: 0	Save...
	Colorize
	☑ Preview

Adobe Photoshop Hue/Saturation Lightness adjustment.

Benidorm, Spain, 1997 (facing opposite)

Parr achieved the rich 'seaside' intensity of colour by combining ring flash (flash around and on the axis of the lens) with the super-saturated Agfa Ultra colour negative film, which is sadly no longer produced.

Photographer:
Martin Parr.

Technical summary:
None available.

Kippford (below)

Desaturating enhances the pastel tones of these cottages in Kippford, Scotland, but to keep some strength in the tractor, a bitmap (black-and-white only) version of the image has been layered in. Some image retouching was performed to simplify the skyline.

Photographer: David Präkel.

Technical summary: Nikon D100 18-35mm f/3.5-4.5D AF ED Zoom-Nikkor, 1/320 at f/9.5 with +1 EV compensation.

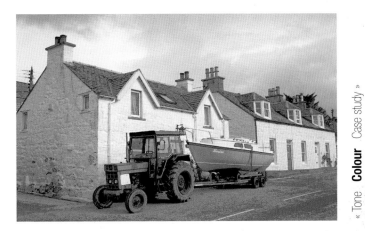

« Tone **Colour** Case study »

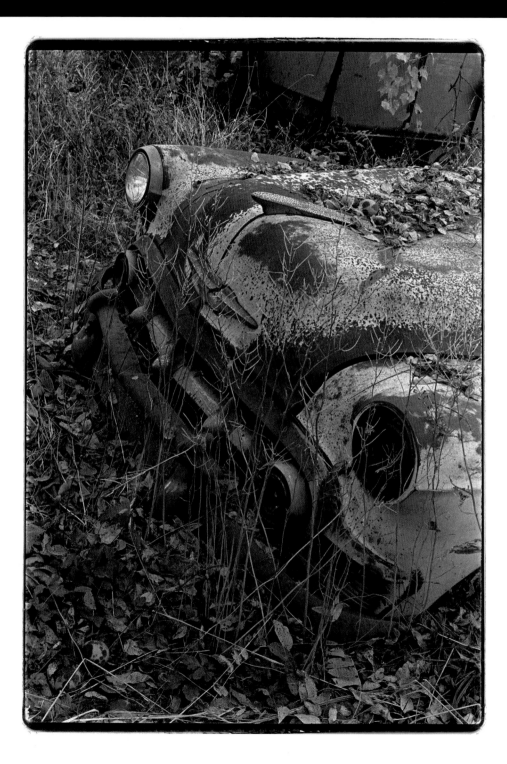

Limited palette

Reducing the number of colours in an image can simplify and strengthen the composition. Artists working in oil paints mix their colours on a palette. For photographers, an image with a 'limited palette' is one that uses only a few shades of one colour.

In landscape photography, where the photographer has least control, changes in weather can produce the best conditions. Mist, fog and rain all reduce the palette of colour, thereby simplifying the subject matter. Moving in closer to the subject and looking more at detail can also reduce the range of tones and contrasts in colour.

Ultimate control over the palette of colours in your images can be achieved by taking your pictures in black and white and then hand-colouring them. This is either achieved with oils or washes on silver gelatin prints made on fibre paper or on the computer. Marshall's photo oils and oil pencils are probably the best-known products for true hand colouring. Specialist suppliers still stock felt-tip and brush-tip photo dye pens; alternatively, bottled dyes and retouching kits are available and the dyes applied diluted with a brush.

The image-manipulation technique is to scan a greyscale image and convert the image space to RGB. Using selected colours from the Color Picker or, better still, sampled colours from other images, you paint these colours into the image using a range of soft-edge brushes on layers with the blending mode set to Soft Light or Color. Adjusting the opacity of the brush or layer introduces more subtle effects. Keeping each colour on a separate layer enables you to adjust the hues of the colour palette on each individual layer.

Waterloo Bridge, London (left)

A misty evening light and a telephoto lens limit the palette of colours in this atmospheric scene on the River Thames.

Photographer: David Präkel.

Technical summary: Leica R4, 180mm f/4 Elmar-R, Ektachrome 100.

Hand-coloured car (facing opposite)

A digital hand-coloured image of an abandoned station wagon on a ruined farmstead, in Ovid, New York. Colours for this image were sampled from a second image of fallen leaves.

Photographer: David Präkel.

Technical summary: Leica R4 35-70mm f/4 Vario-Elmar-R, Kodak TMax 400 black-and-white film plus colour sampled from second image on Elitechrome Extra Colour film.

Black and white

For many years black-and-white film was the only acceptable medium for fine-art photography. Colour images were regarded with deep suspicion until William Eggleston's groundbreaking exhibition at the Museum of Modern Art in New York in the early 1970s. While colour has its place, black and white still represents the ultimate in photographic abstraction. Black-and-white images are not just colour images with the colour drained from them; they represent tonality, shape and texture more explicitly. Black-and-white photography is about the presence or absence of light and its creation of texture and form.

We do not see in black and white, so predicting the look of a black-and-white image is largely a matter of experience. Screwing up the eyes and squinting reduces their colour performance to some small extent, which can help with visualization. The way in which monochromatic film responds to different wavelengths of light – different colours, in other words – gives it its characteristic look. For many photographers film has a unique, inimitable quality. Film's sensitivity to colour can be manipulated by using coloured filters over the camera lens: filters of a similar colour to the subject lighten, opposite colours darken. On black-and-white film, for example, a yellow, orange or red filter would darken a cyan/blue sky, while a yellow-green filter would lighten foliage.

Digital black and white is becoming increasingly popular, although the image is always originated in colour and converted to black and white using software. The practice of shooting black-and-white film can be a great help in visualizing tonal relationships and in seeking out subjects worthy of monochromatic presentation. Black-and-white photography offers a compositional discipline that will improve all other forms of image making.

'When you photograph people in colour, you are photographing their clothes. When you photograph them in black and white, you photograph their souls.'
Ted Grant (Canadian photographer)

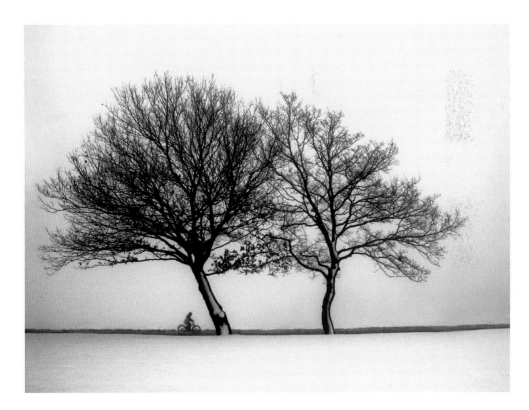

Foggy evening (above)

There is nothing that colour could add to this image and much it would take away. Form, scale and shape are all made abstract and enhanced by careful subject selection and the use of black and white.

Photographer: Ilona Wellman.

Technical summary: Nikon Coolpix 5700, 1/250 at f/5.0 using the black-and-white mode and contrast and levels adjusted.

Warmtone and cooltone

Black-and-white photographic printing papers come in a range of tones, varying from brown-yellow blacks to blue blacks. The brown end of the scale is referred to as 'warmtone', while the blue end of the scale is called 'cooltone' or 'coldtone'. Paper developers are also known as 'warm-' or 'cold-working'. These distinct looks can easily be achieved with digital images. Additional chemical toning was originally introduced to preserve black-and-white prints, but there are also aesthetic reasons for chemical toning or the digital equivalent. With silver-halide based images the silver salt is chemically altered by toning to produce a range of brown- or blue-toned images – perhaps the best-known toning process being sepia. Alternatively, the silver can be substituted or augmented by another metal, such as selenium. This produces a range of potential greys from graphite to a rich purple grey, depending on how long the print is left in the toner. Toning with gold, copper, iron and chrome have all been popular in the past – at least with photographers, if not always with health-and-safety experts.

In a fully toned image all the blacks and greys will turn to shades of brown; in a split-tone image the lighter parts of the image are brown but the darker tone is more like the original black.

Split-toning using sepia and selenium is possible and has particular appeal. All these chemical effects have a characteristic look that can be easily duplicated with image-editing software for digital images.

Selective toning of black-and-white paper prints can be a very hit-and-miss affair. Colour is laid down on selected parts of the subject only – one leaf from a carpet of leaves, for example. This treatment is so much easier to achieve digitally, without the need for careful applications of fast-acting chemical, or elaborate masks laid with rubdown sheet or painted on as liquids.

Warmtone and cooltone effects (below)

Cooltone (bluish) < Neutral grey > Warmtone (brownish)

Underground (facing opposite)

Image of the London underground that uses the 'language' of warm and cold tones to contrast the cold-blue corridor of the tube station with its warm, yellow depths.

Photographer: Tom McGhee, Trevillion Images.

Technical summary: Nikon F5 20mm f/2.8 AF-D Nikkor, exposure not recorded, colour negative film was cross-processed in E6 chemistry.

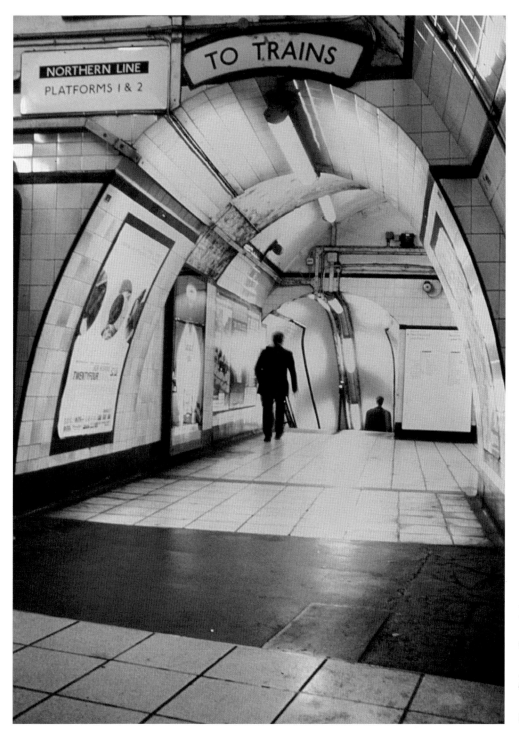

Aesthetics and the formal elements

First impressions can be misleading. At a casual glance this image could be an advertisement for a popular soft drink. Pausing and looking a little closer you begin to notice the sheer individuality of this bottle, which bears the marks around its body where it has been put time and again into crates. The glass shows tiny chips and fractures, creating a history for this item that moves it beyond the anonymous – often hyper-real – image of a bottle one would find in an advertisement. So what is going on here?

Surprisingly, this image was not taken by a single photographer but was a collaboration between students helped by a phototechnician. This was part of a learning exercise in museum studies. The intent was not to create a pleasing image. In fact the image was not intended to have a formal aesthetic quality at all; rather the intention was to create a record photograph of this object as if it were a museum exhibit. The lighting reveals detail and emphasizes the formal elements and

it is to these amplified characteristics that viewers may begin to respond.

Some photographers intentionally seek out and emphasize the flaws and characteristics of individual, often mass-produced objects. French-born photographer Patrick Tosani has explored this idea of bringing the everyday and mundane into the realm of the aesthetic. Zen philosophy also contains a concept of beauty in transience and the idea of finding beauty amid the flawed and 'everyday'. Borrowing the Zen phrase, this may be encountered in photographic criticism as 'wabi-sabi aesthetic'.

It is important to remember that viewers will bring their own visual literacy, personal experience and history to your images and maybe, as here, create an aesthetic that is not intended. Their reaction is entirely valid though may not be what you intend to be read into your composition.

Lush Coke (facing opposite)

At first sight this is good enough to be an advertisement, but look closer; something marks this image out as special.

Photographer: Marthe Fjellestad and other students with the help of a photographic technician.

Technical summary: Hasselblad H3DII-31 80mm f/2.8, 1/160 at f/14, ISO 200.

The single object exercise was traditionally a test of camera and lighting skills on technical photography courses but it can be extended to stretch compositional skills as well. Any photographer can benefit from this exercise, the possibilities being endless.

First, pick a simple single object. We have chosen an egg. The aim is to explore the subject in a series of images each revealing one aspect of the subject, initially working through the formal elements discussed in this chapter. The exercise can then become more sophisticated by including a second object, bringing meaning to the first. Plan your ideas first as simple thumbnail sketches.

Our series of images starts with a representation of line (1), using the transition between the tone of the flatly lit egg and the background. Care was taken with the choice and position of the curve in the image and to keep as much of the egg out of sharp focus as possible. The exercise moves on to 'form' (2), using one spotlight to create a single highlight and a strongly defined shadow. The gradation of tones created across the eggshell allows the eye and brain to rapidly reconstruct the form of a three-dimensional object. Flat lighting (3) shows the overall shape of this particular egg while strong side lighting (4) explores textures.

Only then is colour introduced, with the egg being lit to produce the richest colours subtly shading across the shell (5). Scale is depicted in the form of an oversize spoon, maybe introducing a touch of humour (6). The seventh image examines similarity/dissimilarity by posing the egg with a wooden egg; an egg-shaped pebble would be another possibility. Key is then considered in a high-key image strongly lit with two additional slave flashes (8); the daisy introduces a dissimilar shape, confirming the delicate high-key look while contrasting in texture and colour.

Contrasts are explored further in the final image. (See page 140 for a list of contrast ideas that can be used to take this simple one subject exercise in many different directions.) This is a confrontation between the strong shape and hard qualities of a knife blade 'stopping' the egg that is reared up as if it was trying to avoid being pierced. Formal elements are now being blended in a more considered, constructed image where narrative is beginning to take over, though the geometry of the composition has been equally carefully chosen.

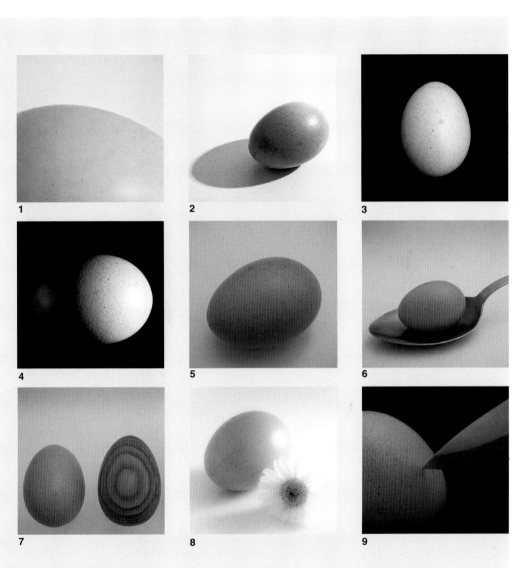

One egg (above)

Exploration of the formal elements (reading left to right and top to bottom), line, tone giving form, shape, texture, colour, scale, similarity/dissimilarity, high-key and contrasts.

Photographer: David Präkel.

Technical summary: Nikon D700 60mm f/2.8D AF Micro-Nikkor, 1/50 at f/4 (first image only, with modelling light alone), 1/160 at f/25-29 single Multiblitz flash head with reflector, bare bulb or snoot, high-key image uses two slave flash heads and a light tent, ISO 200.

Organizing space

Composition is a process of organizing. This section of the book looks at ways in which photographers can organize compositional elements in space. All photographic imaging starts with selection, but before the photographer even thinks about a subject, he or she must give consideration to the proportions of the frame that will contain it. There are various film and digital formats and a choice of aspect ratios for frames. The frame of the image can be horizontal (landscape), vertical (portrait), square or panoramic, the latter offering the photographer a particular challenge with composition.

Having picked a subject, the photographer needs to know where the subject is best placed in the frame and how much of the frame it should fill – as both subject position and size have a major influence on how the viewer will read the image. The advantages of composing images in the camera over cropping in the darkroom or on the computer are explained here.

The photographer must also consider the balance of all the formal elements and the foreground-to-background balance within the frame. We'll look at symmetry, reflection and the pitfalls of the perfectly balanced image – in addition to related notions of symmetry, beauty and the human face – in more detail in the next few pages.

Selective focus and the use of lens aperture give photographers control over which part of their image appears in sharp focus – a feature unique to photography. Sharpness, by convention, signifies the importance of the subject. Again, we'll look in more detail at focus, the quality of out-of-focus areas of the image and the use of depth of field and hyperfocal focusing to maximize sharpness.

Cityscape (facing opposite)

In his cityscape images Zafeiris says he is trying to capture the 'unseen'. This image at first presents a void between the near barrier of the yellow parking lines and the distant monument and its temporary red plastic fence. These elements 'hold open' a space that only on further investigation reveals intriguing textures.

Photographer: Sotiris Zafeiris.

Technical summary: Canon EOS D60 Sigma 15-30mm f/3.5-4.5 EX DG 1/90 at f/5.6 ISO 200.

Frames

Framing a section of the world to create an image is arguably the most important part of the process of composition. The proportions and orientation of the frame (horizontal or vertical) dictate how the process of composition proceeds. Each format has its own 'sweet spots' in the frame that may demand a different approach in terms of subject placement.

Rectangular images are commonplace, though this has not always been the case, as lenses project circular and not rectangular images. The proportions of a rectangular frame is known as its 'aspect ratio' – width divided by height – more often written as two whole numbers e.g. 3:2. Using the golden mean, the ideal would be a 1:1.618 rectangle. The table on page 93 shows how the 6 x 9cm, full-frame digital and 35mm formats come closest to this notion of the 'ideal'.

1

2

3
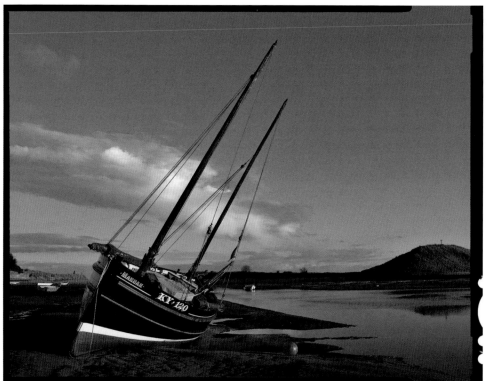

4

5

6

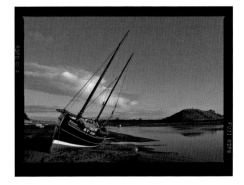

7

Film type	Format	Aspect ratio
1	Digital SLRs (full frame and APS sensors) and 35mm film	1.5
2	Four thirds (4:3) digital cameras (17.3 x 13mm sensor)	1.333
3	5 x 4in and 10 x 8in – large format film	1.25
4	6 x 9cm – medium format roll film	1.5
5	6 x 7cm – medium format roll film	1.286
6	6 x 6cm – medium format roll film	1.0
7	6 x 4.5cm – medium format roll film	1.333

Sheepherder on the banks of the Yellow River, China (above)

Positioning the subject close to the frame edge creates tension, while the use of a wide-angle lens puts the viewer uncomfortably close to this man gagging on the stench of industrial pollution.

Photographer: Lu Guang.

Technical summary: None available.

Location in the frame

It is important to think about the shape of the chosen subject and to judge how it can be visually separated from the 'field' or background. There is a natural tendency among beginners to place the subject centrally within the frame, with a little breathing space between it and the top and bottom of the frame – known as 'bull's eye syndrome'. With most formats, this position leaves two large redundant areas at either side of the subject. This framing has an almost magnetic quality and, at first, it becomes a hard fight not to frame all subjects in this way. There are times when it is appropriate – see the section on symmetry (page 110) – but the visual argument has to be compelling.

Trying consciously to move the subject off-centre towards one of the four corners of the frame begins to free up the composition. A more radical solution might be to crop the subject so it is only partially present in the frame, creating what in known as an 'open' composition. A 'closed' composition is where all elements are contained within the frame producing a different psychological effect. Geometric considerations such as dynamic symmetry can help, but the where and why will be dictated by the subject.

Depending on the subject, it will lay claim to part of the space around it. In the expectation of its moving off, a car will 'own' the space in front of it. Objects also tend to dominate the space over which their shadow falls. In portraiture, it is essential to consider the space in front of and behind the head, especially with profiles, as the effect created can be dramatically different – the profile close to the frame appears argumentative, while space in front of the profile confers thoughtfulness.

With some photographic genres, it is difficult to break down the image clearly between subject/field. In landscape photography, for example, the subject is the field, although care still must be taken with the placement of key elements.

1 2 3 4

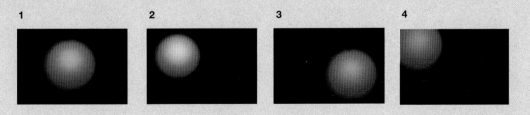

Where in the frame? (above)
1 Symmetrical and static; 2 Offset to top left, which creates some tension; 3 Offset to bottom right, which creates little dynamic or tension; 4 Offset to top left and cropped, which is more dynamic and uses 'closure'.

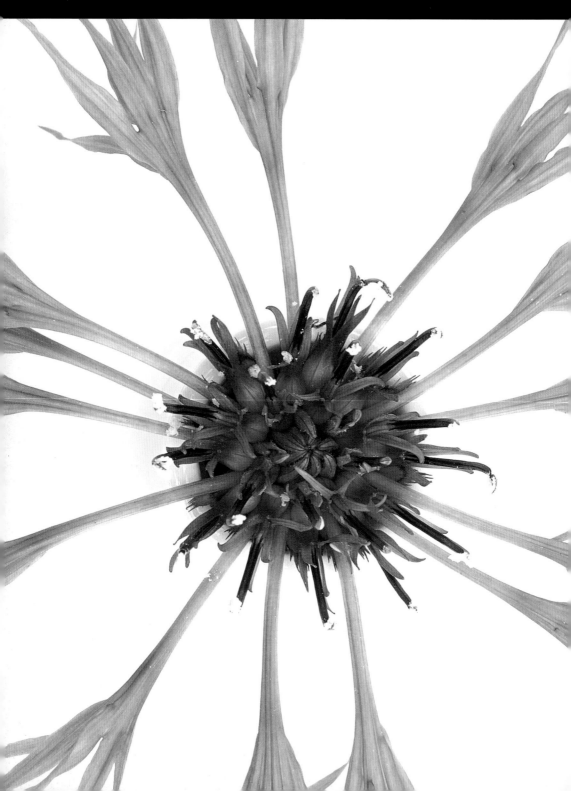

Size in the frame

In addition to its place in the frame, think about the relative size of the subject to its field. What do you want to say about your subject and its location? Do you want the subject to dominate the frame or merge with the background? If your subject is a flower bursting with colour and energy, maximize it so that it bursts out of the frame.

Just as there is a mesmeric attraction to placing a subject in the centre of the frame, we have also a natural reluctance to crop. Timidly nibbling at the edges of a subject produces weak images. Important detail must be retained, but the brain will rapidly complete what has been cropped out, especially with geometric or common forms. Newspapers rarely publish a head and shoulders portrait without cropping through the forehead. This gives more prominence on the page to the face. Ideally, cropping is performed in-camera as this gives the best-quality full-frame print.

Exaggeration is one of the photographer's most powerful tools. Cropping a subject tightly for maximum detail and impact is one such example. If appropriate to the subject, show the subject as small as possible in the frame – just large enough to be recognizable. Put a camera in the hands of a child and they appreciate and explore these extremes with little regard for convention, and it is worth putting it aside with your own photography, in order to explore the limits. Further ideas can be found in the section on scale (see page 28).

Moving the camera relative to the subject and changing the focal length of the lens alters the relationship between subject and background, as shown in the exercise on perspective (see page 32). Alternatively, if you want to crop an image, don't move the position of the camera, but use different focal-length settings on a zoom lens to achieve different crops.

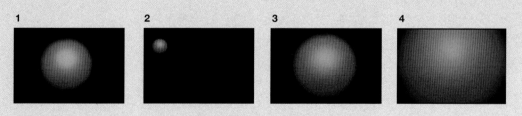

1 2 3 4

What size in the frame? (above)

1 Symmetrical, with redundant space to the left and right; 2 Small, but still recognizable subject embedded in its environment, which is more interesting; 3 Symmetrical, frame-filling subject becomes uncomfortably close to the top and bottom edges of the frame; 4 Finally, a strong crop around the subject retains its identity, but also packs the frame with detail.

Cornflower (facing opposite)

This cornflower is intentionally overexposed by one stop to lose all but the faintest trace of the white circular vase. Exuberant, frame-filling detail – two petals remain to show what has been cropped elsewhere.

Photographer: David Präkel.

Technical summary: Nikon D100 60mm f/2.8D AF Micro, 1/3 at f/22, natural light with wraparound reflector.

Composition in-camera

It is a good discipline to give as much consideration to the film or sensor area as possible when creating the image. This is called in-camera composition. Full-frame images that need no cropping make the best-quality enlargements or prints.

It is far easier to compose in-camera when the camera viewing/focusing system is an image projected onto a ground-glass screen that the photographer views directly. This puts you at one remove from the real world and begins to produce the look of the final two-dimensional image. Medium- and large-format cameras work this way, and many also invert or flip the image (depending on the type of camera). This can be hard to get used to or just another stage in the process of abstraction, depending on your point of view, but some photographers prefer this method of composition.

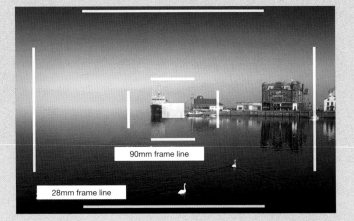

90mm frame line

28mm frame line

The extended view of the viewfinder or rangefinder camera can help with both framing and timing.

The SLR (single-lens-reflex) camera presents a view close to the final image, because you are looking through the picture-taking lens. This is especially true if the camera has a depth-of-field preview button and the effect of the taking aperture can also be assessed. The effects of filters over the lens also show.

In comparison to SLRs, viewfinder or rangefinder cameras can only show the effect of alternative lenses as frames within an overall fixed view. You are also not able to judge the effect of depth of field. If the viewfinder is set some distance away from the taking lens on the camera body it will not frame exactly the same view – the closer the camera gets to the subject the worse this effect, known as 'parallax', becomes. However, the view/rangefinder camera has one major advantage over other viewing systems in that it shows what exists or is occurring outside the frame. This enables the photographer to track compositional elements as they come into frame. Cartier-Bresson was a master of this form of composition and spent his working life using Leica rangefinder cameras for this reason (see opposite). His images are often reproduced with the black frame border, which emphasizes their composition in-camera.

'To me, photography is the simultaneous recognition, in a fraction of a second, of the significance of an event as well as of a precise organization of forms which give that event its proper expression.'
Henri Cartier-Bresson (French photographer and painter)

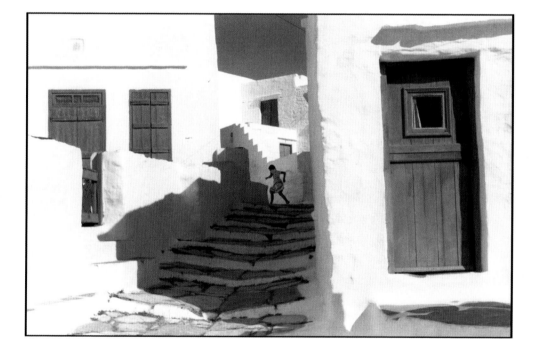

Sifnos, Greece, 1961 (above)

Everything comes together in the viewfinder frame at the 'decisive moment'. Form, tone, space, line and texture are balanced, waiting only for the 'actor' to take centre stage.

Photographer: Henri Cartier-Bresson.

Technical summary: None available.

Horizontal format

The horizontal rectangular frame is known as 'landscape' format because it is this subject with which this format is most strongly associated. Landscape format emphasizes the horizon and any part of a horizontal line or plane in the image; it encourages broad vistas and, as a shape, lends an image a sense of stability and direction.

Portraits taken in the horizontal format leave potentially redundant areas on either side of the subject. The face will also be smaller in the frame than it would be in 'portrait' format. However, moving the subject to one side opens up background detail (in or out of focus) that can provide interesting context. The horizontal format offers greater opportunity to include space in front of or behind a head in profile and can be used to create tension if the face is placed near a corner or edge and appears to be moving out of the frame.

The vertical centre line of the horizontal frame always seems a compositionally 'dangerous' place to split an image. The exact centre line becomes an axis that challenges the viewer to compare the two halves. It can provide a strong fulcrum about which the image turns but there must be a thoroughgoing composition or the picture will end up simply as two halves.

Vertical format

The vertical rectangular frame is known as 'portrait' format, because it comfortably encompasses head-and-shoulder portraits. This format emphasizes any vertical line or plane and exaggerates foreground-to-background depth. For this reason alone, images of urban landscape are often composed in vertical format to emphasize the 'concrete canyons' of a city.

The vertical format makes for more dramatic diagonals than landscape format, as the angles within the frame can be steeper. When the subject is a landscape, the vertical format can be used to emphasize a gorge or rocky outcrop, especially when coupled with a high viewpoint. With its exaggeration of depth, the vertical frame is ideally suited to large-format images full of extensive, sharp detail, from the foreground to the far distance, for which hyperfocal focusing and a camera with a tilting back or lens board are essential.

Vertical format is ideal for the standing human form and can comfortably and elegantly encompass gestures and movement.

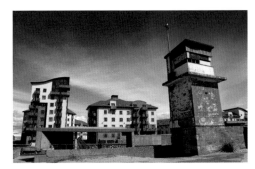

Carrshield (above and below)

The low horizon and farm building just tucked into the dip in the hills in the background serves to emphasize the sky. The vertical format provides an opportunity to include the foreground drystone wall. Hyperfocal focusing is important to retain sharp front-to-back detail.

Photographer: David Präkel.

Technical summary: Nikon D100 with 18–35mm zoom, 1/400 at f/11, and 1/250 at f/11.

Dockland development (above and below)

The low viewpoint and strongly converging verticals stress the verticality of the scene, even in this horizontal composition. Moving closer to the old dock lookout needed a higher viewpoint to keep the converging verticals within acceptable limits.

Photographer: David Präkel.

Technical summary: Nikon D100 with 18–35mm zoom, 1/750sec at f9.5, amd 1/500 at f11.

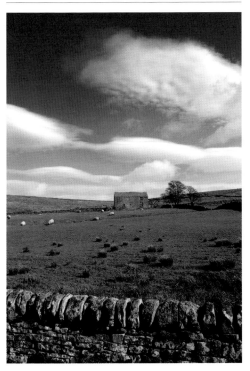

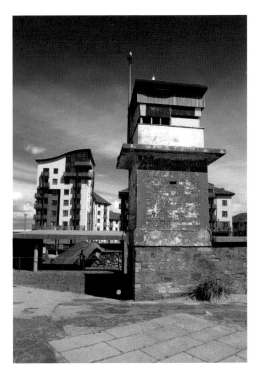

Frames Balance »

Palo Verde Tree, from 'Slab City' portfolio (above)

Slab city is a squatter community in an abandoned marine camp in the Colorado Desert in southeastern California. Martin's purposeful use of square format brings a still-life sensibility to this 'horrific and romantic landscape'.

Photographer: Claire Martin.

Technical summary: Hasselblad 501 CM Planar 80mm f/2.8 CF Fuji Velvia 50. Graduated ND filter for sky, taken at maximum aperture.

Square format

With the exception of some reintroduced Polaroid-compatible instant films, the only square format currently available is the 6 x 6cm image on medium-format roll film. Working with square format has one major advantage – you never have to turn the camera on its side. The disadvantage is the temptation to compose either horizontally or vertically within its confines and to crop when printing. This approach either disregards or misunderstands the quality advantage of the greater film area; the shot might as well have been taken on another format. Square images can, of course, be created later by cropping other formats, but the resulting images may not be as rigorously composed as those formatted to a square in-camera.

Square images are symmetrical about both the horizontal and vertical axes, lending solidity and stability. The resulting quarters are also squares, and the whole form is strongly directed around the centre, which can lack dynamism. The diagonals, however, can be used to dramatic compositional effect.

Where the subject is appropriate, the square can be a rewarding format. In some fields – plant and flower photography, for instance – the square works well, offering big, symmetrically placed and tightly cropped images, although it can be a challenge to avoid composing something repetitive and stereotypical.

For the landscape photographer the square can create static images with little tension, irrespective of where the horizon is placed, although with a wide-angle lens and a viewpoint that includes plenty of foreground, the square format can produce images imbued with great strength.

Having parts of the subject radically break through the square frame can add dynamism. Intentional compositional imbalances between contrasting areas, such as jagged lines and edges or richly curved shapes that extend beyond the visible frame, can unsettle the square format and be used to great creative effect.

Mummified frog with dried flower of the Hoya carnosa (left)

Uncomfortable angles push against the boundaries of the severe square crop from a 5 x 4in negative.

Photographer: David Präkel.

Technical summary: Sinar F with 150mm Symmar lens, 1/8 at f/32, Ilford FP4 Plus sheet film, digital print.

Frames Balance »

Panoramic format

'Panorama' means an unobstructed view in all directions. Interestingly, some of the most dramatic panoramic images are taken not as horizontal images, but as striking vertical compositions. This can be especially impressive with urban and industrial landscapes. It is important to compose a coherent image across the full width of any panorama and avoid leaving sections at each end of the composition that add little or nothing to it.

Despite their long history, panoramas still have a novelty value over and above the quality of their composition. Creating coherent panoramic images relies a good deal on careful location scouting and selection of viewpoint, and the effect is often difficult to visualize. The wide format can create enough compositional problems in avoiding what widescreen filmmakers disparagingly call 'washing-line' – a composition in which a number of smaller, self-contained images compete within the panoramic frame.

The extreme panorama, familiar to most of us from school photographs, is most often taken with a camera using a travelling slit shutter that opens and moves to create the exposure. These, and specialist rotating cameras, create true panoramic images, but are often used in scientific rather than artistic or commercial applications. Fixed lens cameras do not give quite the same coverage, but their conventional shutter avoids movement blur with the rotating lens, which captures the panorama over a specific, if short, period of time. 6 x 17cm and 6 x 12cm are common roll film panoramic formats with 1:2.833 and 1:2 aspect ratios respectively. The now discontinued XPan format, from Fuji and Hasselblad, gave 24 x 65mm (1:2.7) panoramas on 35mm film.

Almost every digital camera is bundled with software that stitches panoramas out of a series of overlapped images, and many cameras feature 'panorama assist', which shows the appropriate overlap on the camera screen. Image-editing software enables users to 'photomerge' images taken at precise rotational angles, but rather than squaring up and cropping the resulting image, it is sometimes more interesting to leave the stepped edge, revealing where each image fits into the composite panorama. Panoramic photomosaics created from multiple images from digital camera phones are becoming increasingly popular.

Barn door (right)

The vertical XPan film format accentuates the vine reaching for the light in this study of line and colour. This is essentially an outdoor still life brought to dynamic life by the choice of a wide-angle lens that gives a strong diagonal line to the lighter foreground fence, also adding depth to the image.

Photographer: John Barclay.

Technical summary: Hasselblad XPan 90mm lens, 1 sec at f/11.

iphoneography (facing opposite)

Composite panorama composed of multiple cell phone images.

Photographer: John Barclay.

Technical summary: Twelve Apple iPhone images combined in Photoshop.

Frames Balance »

'**Photography is a system of visual editing. At bottom, it is a matter of surrounding with a frame a portion of one's cone of vision, while standing in the right place at the right time.**' John Szarkowski (American photography curator and critic)

Frames within frames

One of the most common pieces of advice is to 'frame your subject'. Some photographers might be said to have made a career out of this device – for example, the self-portraits of Lee Friedlander show him framed in reflections, or even framed by picture frames hanging in a shop window. His photo essay 'The Little Screens' comprises a remarkable series of images of television sets – our ultimate framing device – their light illuminating the rooms in which they are set, but the images they carry often contrast sharply with the contents of those rooms.

When we take a photograph we frame a portion of the real world. Painters create secondary framing devices within the overall frame of the canvas and photographers have also found a rich source of imagery in this technique, creating 'the image within the image'.

Taken to its extreme, the photographer can find multiple frames within an image. A good example would be of an image taken of the side of a ferryboat, revealing the disparate lives of the individuals and groups of passengers framed by the openings through the deck superstructure. Coach, bus and train windows, apartment blocks, and open-plan offices have all been used as vehicles for this technique.

A subject-framing device in the foreground will add foreground-to-background depth in an image – overhanging tree branches are often used in this way in landscape photography. This type of framing, however, unless executed sympathetically, may be little more than a visual cliché. The least attractive attempts at framing are where individual parts of branches hang into the frame like a fringe and do not seem connected to any visible tree in the image. Far better is to show the tree trunk to the side of the frame with its overhanging branches to the top.

Street in Old Beijing, 1965 (facing opposite)

Classic photographer's device of using frames from the real world – in this case, the window of an antiques shop – to create a series of disparate, but connected, images within the camera's single frame.

Photographer: Marc Riboud.

Technical summary: None available.

Frames Balance »

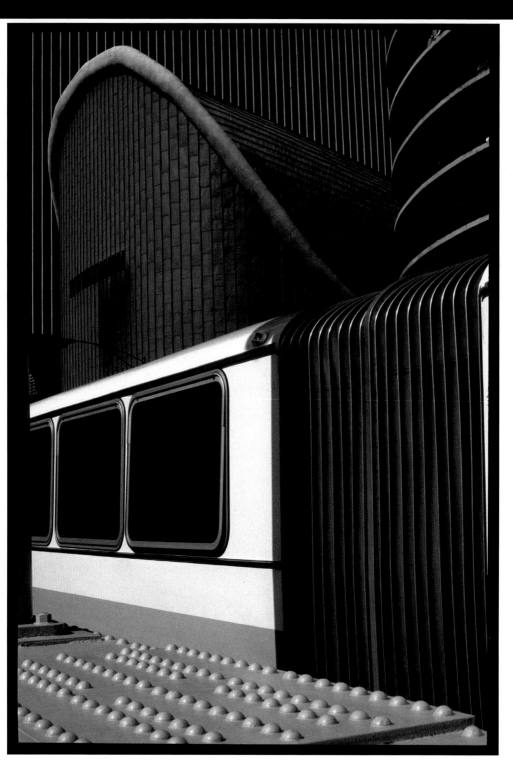

Balance

Balance is one of the main principles in design and in formal painting. The test in painting is to draw a vertical line down the centre of the image and look for a balance between the two sides. Photographers do not necessarily seek the same degree of classical harmony and may add tension to the image by shifting elements of the image to create imbalance. An image balanced by weak elements is static, while an image showing balance between strong elements is much more dynamic. The strongest sense of balance will come from the distribution of tones (light to dark) in the image. An image with a strong concentration of light or dark tone to one side of the frame, without balancing the tone, will create visual tension.

Balance does not always have to be judged about a central 'pivot'. A strong compositional element away from the centre will divide an image into two unequal parts and shift the visual pivot. 'Heavier' details, such as dark tone or areas of concentrated detail, will have a much stronger effect closer to the pivot point. Elements closer to the edges of the image will also gain compositional 'weight' or significance.

In addition to balancing elements from left to right of the frame, don't forget the balance of depth between foreground and background elements. More distant (and therefore smaller) objects with stronger tone, colour or detail will balance less prominent (though larger) foreground objects. Images with great apparent depth will require a judgement call on the balance of three-dimensional space within the image. It is often easier to assess shapes and space by turning the print upside down or flipping a digital image vertically or laterally.

Bus form (facing opposite)

Balance in this image is provided by the articulated bus and the distinctive architecture of House of Blues and Marina City, Chicago. Circles work against rectangles, curved lines against straight lines and blocks of tone and texture about a roughly central line. There are similar textures in both foreground and background.

Photographer: David Präkel.

Technical summary: Nikon F2A with 55mm f/2.8 Micro-Nikkor, exposure not recorded, Kodachrome 64.

Symmetry and reflection

Symmetry is the property of an object or image in which both sides are equal but opposite about a central dividing line. Many buildings and the human body, for example, have this two-sided (bilateral) symmetry (if imperfectly in the latter case), while many flowers are radially symmetrical about any line that cuts through their centre.

Symmetrical compositions are initially very appealing and they have a strong sense of structure, although their strength is also their failing as all forces are equal and opposite. Though superficially attractive, they can be too easy on the eye and lack tension.

It is a challenge to avoid centring the subject symmetrically in the frame, but this invites the viewer to simply compare the mirrored halves of the image rather than interpret the image as a satisfying whole. Nearly is not good enough with this kind of image, and the alignment of the axis of symmetry and the equivalence of the two halves has to be perfect. Symmetry of line, or of shape, must be accompanied by perfect symmetry of pattern, colour or texture.

Plenty of research has been conducted to show that a symmetrical face with a good balance between the two halves is considered beautiful. Any asymmetry in the face is considered to have 'character', but any great imbalance in the features becomes a source of discomfort for the viewer. It is important to remember these deep-rooted psychological responses when taking portraits.

Reflections can be used to create a second half to an otherwise unsymmetrical scene. Photographers sometimes stretch the viewer's perceptual powers by taking a picture of only the reflection, to force the eye to make out what real-world objects created that reflection.

Underpass (facing opposite, top)

Presented upright, this image of a reflection in a puddle in an underpass gets us guessing about the true nature of the real world it reflects.

Photographer: Wilson Tsoi.

Technical summary: Canon A80, 1/25 at f/5.6, White Balance Cloudy, ISO 50, with minor saturation adjustment.

Beyond fashion (facing opposite, bottom)

The young model was shot out of hours in a restaurant play area. The photographer uses a strongly symmetrical composition, contrasting colours and quirky posture to bring a sense of fun to this self-initiated student project on shoes. The intense colour saturation comes from using ring flash, which delivers crisp, shadow-free lighting.

Photographer: Caroline Leeming.

Technical summary: Nikon D100, ring flash, 1/125 at f/8–11 ISO 200.

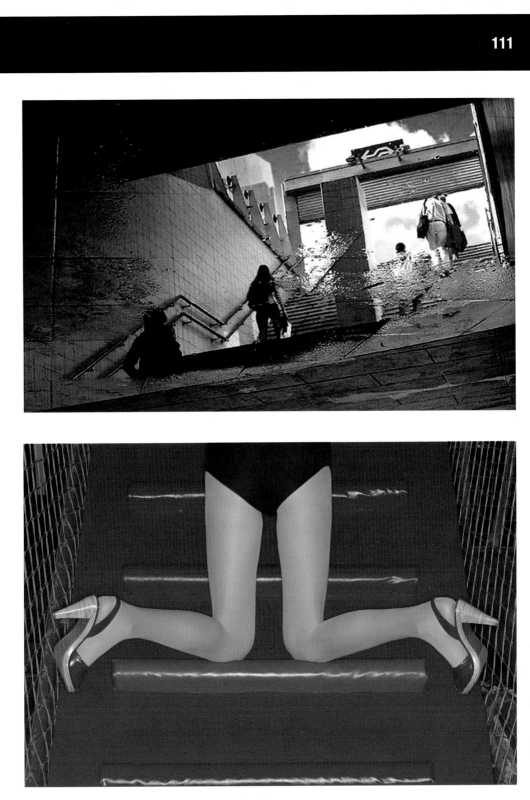

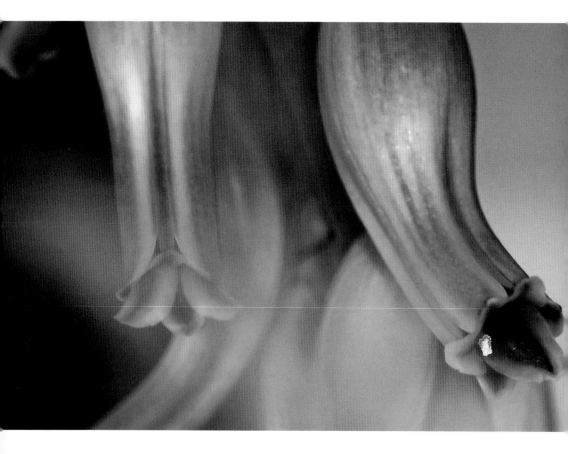

Agave flower (above)

The soft focus in this image emphasizes shape, form and colour, and gracefully smudges foreground detail.

Photographer: David Präkel.

Technical summary: Nikon D100 70-300mm f/4-5.6D AF ED Zoom-Nikkor with Nikon +2.9 dioptre supplementary close-up attachment and SB-29 ring flash. Limited depth of field despite small aperture 1/180 at f/22, reduced further by focusing just in front of main flower. ISO 200.

Appearance of space

Nowadays, photography is called a 'lens-based medium', in recognition of the fact that sharp focus and lens blur are characteristics unique to the medium. An artist can create smudged effects working in paint and pencil, but nothing that corresponds convincingly to progressive lens blur. In photography, it is generally assumed that sharpness indicates significance – although there are image makers who have purposefully subverted this convention by focusing beyond the subject.

Lenses with a long focal length have high degrees of foreground and background blur, even when stopped down, and require critical focusing; very wide-angle lenses almost need no focusing, so great is their apparent depth of field. These differences can influence the choice of focal length – for example, use a long focal length lens where you want to have crisp focus, but a rapid fall off into blur.

The point of focus is important, especially with portraits where the eyes must be in perfect focus. It may be necessary to override the automatic focus on the camera to achieve precise or specific focusing effects. Switching to manual focus or using focus lock are two ways to achieve this.

The quality of the out-of-focus parts of the image can be important – especially in portraiture where a very soft, smooth quality may be required. The lens aperture is responsible for the quality of the blur and it will introduce its own shape into the out-of-focus highlights. The more circular the aperture, the more satisfying the blur. This was first noted by camera enthusiasts in Japan who used the term 'bokeh' to describe the quality of blur in a lens. Lenses which retain a circular rather than a flat-sided aperture as they stop down are highly rated for *bokeh* – the more blades in the lens iris (and therefore the more costly the lens), the better the *bokeh*. Cheap lenses produce six- or eight-sided out-of-focus highlights that can detract from the main subject.

1

2

3

Selective focus (above)
1 Close focus 2 Mid-distance focus 3 Distant focus.

« Balance **Appearance of space** Case study »

Foreground and background

Much landscape photography disappoints the photographer. The results can seem too flat, as if they are bound by the two dimensions of the medium. However, images can entice the viewer into the small, framed world. One way of achieving that is to emphasize the illusion of depth in the image. Simply lowering the viewpoint will connect the viewer to the landscape in a dramatic way. An image taken from a lower viewpoint will emphasize the foreground, increasing the apparent depth in the image. Landscapes taken from a conventional standing viewpoint are more detached from the viewer. Wide-angle lenses favour foreground objects, and enable closer working, yet can show both foreground and background in sharp focus.

In art, any shape that overlaps and hides the background or another shape is a foreground object. Without overlap, the two shapes might be misinterpreted as being side by side on a flat plane. Careful choice of viewpoint can overlap a foreground frame or part of a larger foreground object to increase the sense of depth. This holds good for any form of photography and not just landscapes. Shadows also provide clues about depth, as they recede along the perspective planes of the image.

Limiting the depth of field by increasing the lens aperture will throw the foreground or background selectively out of focus. This shifts the emphasis within the image. Some photographers will intentionally focus beyond the subject in the foreground to create an element of ambiguity or doubt, as the apparent subject will then appear out of focus in front of a sharply focused world.

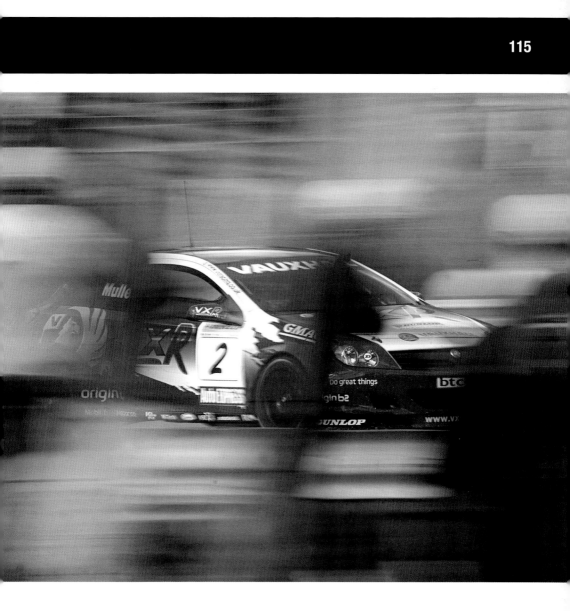

Through the crowd (above)

The subject is in the background, but despite this the viewer 'feels' as though he or she is in there with the driver, former touring car champion Yvan Muller, at the British Touring Car event at Brands Hatch. The camera was manually pre-focused and panned with a slow-enough shutter speed to blur the foreground crowd despite the depth of field available at that working aperture.

Photographer: David Elsworth.

Technical summary: Nikon D100 Sigma 70-300mm f/4-5.6 APO DG Macro, 1/30 at f/22, ISO 200.

Picture it: a quiet bus station one public holiday afternoon. But what grabs your attention is a big, red telephone booth with no phones, no means of communication whatsoever. It makes you think of that sad line: 'Is here no telephone?' from Bertholt Brecht's libretto to the satirical opera *Rise and Fall of the City of Mahagonny* by Kurt Weill. So here's a subject worth exploring. Beginning to respond to the scene, you get the first image almost squared-up when a bus pulls into view.
A couple rush into the scene and quickly kiss to say goodbye. This is all becoming very theatrical. Well you don't wait – you take the picture. [1]

You already know your framing is off but their kiss adds so much more to the image. Here is the direct human contact – that communication so sadly lacking in the primary subject. No time to reframe or take a second image as the kiss lasts only a moment and the couple are on their separate ways.

Reviewing the image on the digital camera back you know you need more height at the top of the roof and better coverage of the wall to the right. This will help create the formal compositional balance you want in your final image. You decide you could recreate the scene, as you want it by producing a composite image on the computer. And as you begin to take the extra images [2], the wind conveniently repositions that paper cup. [3] Composition that could not be done in-camera can now be done on the computer.

All the images were first corrected for lens geometric distortion (this is done to produce a better quality final composite). Three images were then masked and blended as a panorama before final cropping. Some perspective cloning was needed to fill out detail on the office block top left. The final flattened image file was then given its increased colour saturation and contrast 'look' in Adobe Lightroom before corner and edge darkening were applied.

Is here no telephone?
An image composed on the computer from three separate images, yet which remains faithful to the original scene.

Photographer: David Präkel.

Technical summary: Canon PowerShot G9 7.4mm (35mm 35mm equivalent), 1/24 at f/2.8, ISO 200.

1

2

3

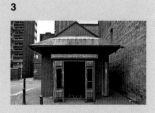

When a lens is fully open (at maximum aperture, small f-number) focus is a very thin plane that drops through the subject parallel to the plane of the film or the sensor in a digital camera. There may be some acceptable sharpness, in front of and behind the true plane of focus, but this may not amount to much.

As the aperture is closed or 'stopped' down (bigger f-number), this apparent sharpness begins to extend further in front of and behind the plane where the lens is focused. This 'depth of field' does not increase evenly in front and behind – at normal focusing distances – as a rule of thumb – it grows one-third in front of the focus point and two-thirds behind. As you focus on a closer subject this becomes more like half and half.

Aperture gives photographers compositional control over what appears sharp and what does not. Throwing the background out of focus is a case for maximum aperture; getting the whole of a flower to appear sharp is a case for carefully focusing some way across the flower head and stopping down the lens to achieve a depth of field that extends over the whole flower. Depth of field is reduced the closer the camera is to the subject, while the longer the focal length of the lens used, the shallower the depth of field appears to be. The depth-of-field preview button (on SLR cameras) will show how much depth of field you will have at the taking aperture – focusing being done at maximum aperture.

Hyperfocal focusing is one way of maximizing depth of field and is often used by landscape photographers to get images that appear sharp throughout. An autofocus camera will often focus on infinity (the furthest point), which wastes a large part of the available depth of field. When a lens is focused at infinity the near limit of its depth of field for the chosen aperture is called the hyperfocal distance. If your lens has one, this can be read off the lens depth-of-field scale. By shifting the focus to the hyperfocal distance the maximum depth of field can be achieved for that lens aperture. If the lens does not have a depth of field scale, revert to the one-third/two-thirds advice.

Try this depth of field exercise outdoors using cars in a parking lot, a row of houses or a fence; or you might prefer a tabletop set up like the one shown here. Focus some way into the image and lock – we chose the strawberry cupcake. Take a set of exposures with your lens wide open (maximum aperture), then stopping down in two-stop increments to the minimum aperture. Use Aperture priority or Manual mode. Get used to using the depth-of-field preview button to see what will appear sharp before you take the picture. Review your sequence as prints or full-screen to judge how your lens performs at different apertures. Try this at different focal lengths.

f/3.2

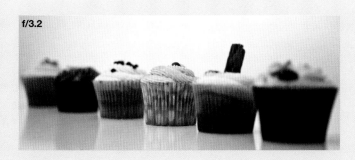

f/5.6

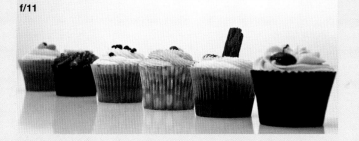

f/11

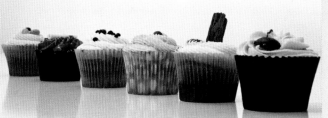

f/22

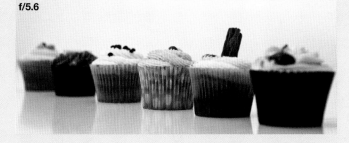

f/36

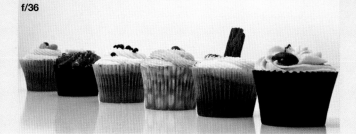

Cupcakes – depth of field (left)

This sequence (top to bottom) was taken at maximum aperture f/3.2 (this lens does not achieve its f/2.8 maximum at this focusing distance), f/5.6, f/11, f/22 and the minimum aperture of f/36. Only in the last frame is the image truly sharp from front to back.

Photographer: David Präkel.

Technical summary: Nikon D700 60mm f/2.8D AF Micro various exposures ISO 200.

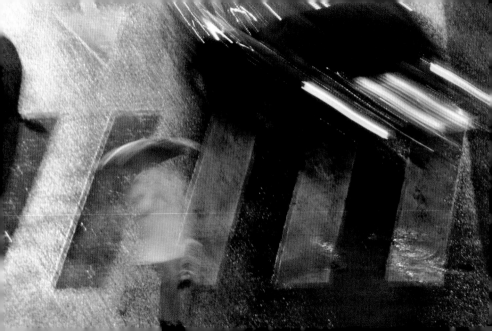

Organizing time

Choosing a point of focus and a lens aperture gives the photographer control over which part and how much of the image is in sharp focus. In contrast, shutter speed gives photographers control over the appearance of motion in the image. The choice for the photographer is either to freeze motion or to emphasize and blur it.

This chapter considers very different approaches to how passing time is shown in images. Slow shutter speeds and longer time exposures can portray the movement of objects through the frame, creating mesmerizing blurs that track the movement of the subject. When one item is still and others are moving, long exposures show a fascinating difference between the one sharp object and visible currents of movement around it.

Fast shutter speeds and high-speed electronic flash have produced unique images that show time standing still, enabling us to analyse phenomena previously unrecorded, such as the passage of a bullet through a piece of fruit or the bursting of a balloon. Modern cameras can combine time exposure and flash to create images where the subject is frozen in a blurry, moving world. There is never-ending appeal in the way the camera seems to stop the clock.

In any photographic situation, there is an ideal or optimum moment to capture the image when the dynamic world and the static elements gel perfectly. This is discussed in the context of photographer Henri Cartier-Bresson, whose work is often associated with the term 'decisive moment'. We'll look at capturing the 'decisive moment' in more detail, and also cover how sequential, rather than single, images can show the passing of time in revealing ways.

Zebra crossing (facing opposite)
The car and pedestrian are both moving through the rain, but their different speeds create diverse effects. The colours, graphic road markings, moving lights and solitary figure create a memorable image that has the quality of a captured glance – a unique conjunction.
Photographer: Felipe Rodriguez.
Technical summary: Fuji Finepix S2 Pro, Nikkor 80-400mm f/4.5-5.6D ED AF VR, 0.3 sec at f/5.3, ISO 1600, contrast increased in Photoshop.

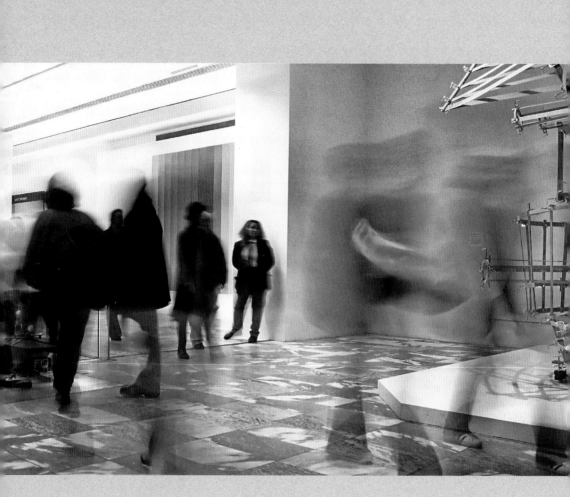

Movement at MoMA (above)

A single exposure integrating time shows the rush and bustle of New York city's Museum of Modern Art – placing the camera firmly on a seat ensured this long exposure recorded the building and exhibits sharply; people moving quickly and close to the camera are see-through.

Photographer: David Präkel.

Technical summary: Leica R8 35-70mm Vario-Elmar-R, f/4 zoom 1s at f/22, Kodak Ektachrome 100.

Time passing

Long exposures will show any movement of the subject during the period that the camera shutter is open. In this way, photographers have learned to depict movement in an otherwise static medium. There is both an advantage and disadvantage to blurred movement in an image. The downside is that detail is lost, but in its favour, the colour contribution to the image may become stronger and the line of motion through the image revealed. Popular effects include blurred tail- and headlights on moving vehicles and the blurred rush of water over rocks or from a waterfall. These image effects have become photographic clichés, but original and creative examples can still be revealing.

With modern, high-sensitivity photographic materials, time exposures need to be made in low-light conditions or with the use of neutral density filters. This is to achieve the long exposure times that will show movement of light and subject during exposure. The effects can vary immensely. For example, a stationary camera can show the movement of a subject against a still background during a long exposure. In contrast, camera movement during a time exposure will create an overall blur.

Exposure times for such effects are – even among professional photographers – largely a case of trial and error or require bracketing (a series of correct, under- and overexposed images) to produce the desired effect. With film, very long exposures cause a breakdown in the linear relationship between exposure time and the amount of light, which can cause unwanted shifts in colour. This is known as 'reciprocity failure'. With digital cameras, long exposures can produce unwanted noise, and many models feature a special long-exposure noise reduction capture setting to moderate this.

Intermittent lighting, from a strobing electronic flash, for instance, can produce a dramatic image effect that looks like a series of overlaid still images of progressive motion. Such techniques have been used in science and sport to analyse motion.

Moments

In the early days of photography, exposures took tens of seconds rather than fractions of a second. But as photographic materials improved to become more sensitive to light, it was possible to reduce exposure times dramatically. This improvement in materials made it possible to slice time into perfectly still moments, forever poised and motionless. Most modern cameras feature shutter speeds of 1/1000 sec or faster and, with appropriate film speeds or ISO sensitivity setting for digital, can freeze the moment. High-energy studio flashes can create a light duration of about 1/10,000 sec to capture something as transitory as a water splash, frozen in time.

Photographic images such as these are endlessly fascinating and bear repeated viewing as they show us something we cannot see with the unaided eye, and also play with our sense of expectation. We know what should happen next, but in the image it never does.

Sports photographers learn to develop the skill of anticipation to capture perfectly frozen moments of play. They focus on a seemingly irrelevant section of grass on a pitch where they wait for the action to occur. Sometimes autofocus – even of the predictive variety – is not fast enough, and they have to rely on manual pre-focusing. Having enough light to be able to stop the lens down to get the subject somewhere in the depth of field bracket is a bonus. Camera panning is sometimes necessary to catch a fast-moving subject. This means moving the camera with the subject, keeping it sharp against a motion-blurred background.

Happy Sunday morning (facing opposite)
She is suspended forever in mid-air with her flailing arms and legs frozen in the moment. The photographer required total concentration to retain the background composition while anticipating where the little girl would bounce next. The subject momentarily stops at the peak of the bounce, which enables the photographer to use a slightly slower shutter speed than would be otherwise required. Strong natural light was balanced with flash.

Photographer: Nina Indset Andersen.

Technical summary: No camera details available. Contrast adjusted in Photoshop.

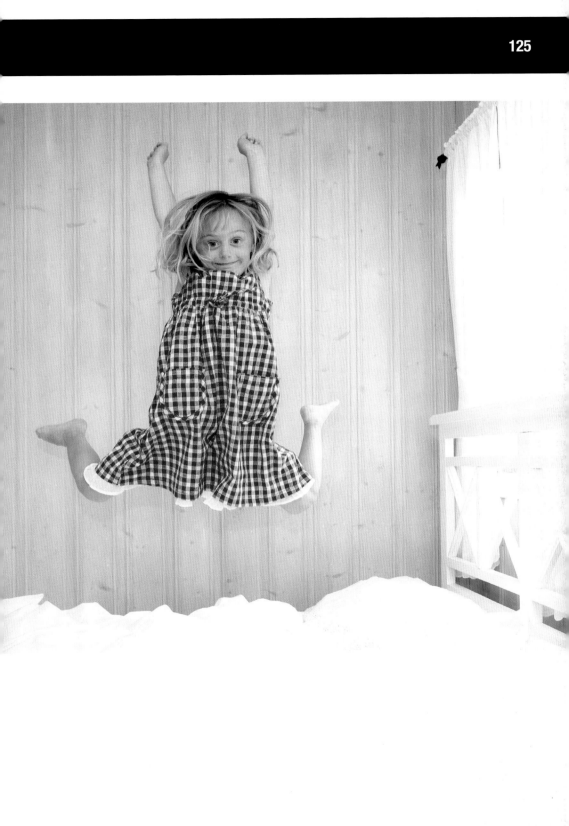

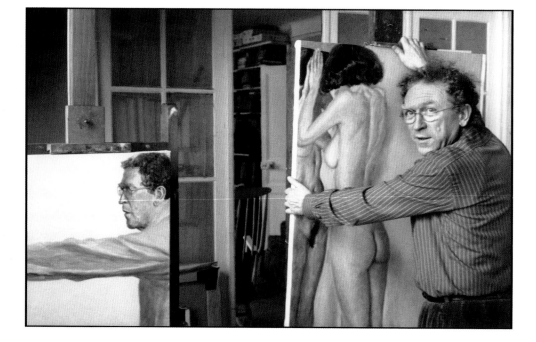

The decisive moment

Cartier-Bresson's 'decisive moment' is a much-misunderstood concept. The phrase was, in fact, coined by his American publisher, an improvement of the literal translation 'Images on the run' for Cartier-Bresson's 1952 portfolio. The 'decisive moment' means that in each picture-taking situation, there is only one moment when all the compositional and emotional elements in the picture coincide at their most powerful – as a photographer, you had better be able to recognize it!

Cartier-Bresson did not simply snap one critical picture, however, but would make a series of images. In a film showing him at work, he can be seen taking pictures almost continuously, without even having his camera – invariably a Leica rangefinder – close to his eye. His talent was to recognize the moment of the coming together of the emotional and compositional elements and to find that frame among his images. To see such arrangements, to trigger the shutter to catch them and to be able to repeat this quality of observation is what makes his body of photographic work so remarkable.

The decisive moment is not simply capturing the peak of the action, as a sports photographer might do. Studying Cartier-Bresson's portraits of artists shows the principle at work. In an extraordinary portrait of the artist Alberto Giacometti, taken in 1961, Cartier-Bresson captures the artist as he unintentionally, but precisely, mirrors his own statues; the long shutter speed emphasizes his movement and separates Giacometti from his work in just one dimension. Similarly, in Cartier-Bresson's portrait of Avigdor Arikha, there is no set up, no posing. It took an instant to capture the moment in which the artist moves a canvas and fleetingly mirrors his self-portrait at the left of the frame.

Portrait of the artist Avigdor Arikha (facing opposite)

Compositionally, it might be argued that this is a poorly created image, with the doorframe and dark band dividing the image down the middle. The right-hand side of the image would stand alone as a superb portrait of the artist; to have matched it to the self-portrait on the left is simply remarkable. The pose of the nude in the painting enhances this uncanny moment, as does the artist's careful, almost reverential, grip on her canvas. Only in this instant has everything come together.

Photographer: Henri Cartier-Bresson.

Technical summary: None available.

Sequences

Control of shutter speed enables photographers to represent time frozen or blurred in a single image. However, some photographers go further in their quest to overcome the limitations of depicting passing time in just one image.

In 1877, photographer Eadweard Muybridge used a sequence of photographs to help settle an age-old dispute. In a series of rapidly taken images, he demonstrated that a galloping horse could have all four feet off the ground at one time. Muybridge used a series of cameras, triggered by the horse running through shutter strings stretched across its path, to produce an elegant sequence of images. Though he was attempting to freeze motion, he had unwittingly laid the basis for creating 'moving pictures'. What fascinated contemporary viewers was the way in which complex actions were broken down into understandable individual images.

Sequences provide the viewer with a way to fast-forward and rewind time by jumping ahead or looking back through a sequence. They show the progress of an event or create a narrative.

Muybridge helped lay the foundations for the movie industry. Although he did not know it at the time, the storyboard format – which shows the unfolding of a story through a sequence of images over a period of time – is now familiar from movie and video planning. Photographers use the storyboard as a source of inspiration – thus, in creative terms, the idea of 'sequence' has come full circle.

In striking contrast to the sequence, it is possible to create multiple exposures in a single image by using a powerful strobe flash that pulses light during a single exposure. With multiple exposures the images are overlaid one on top of the other rather than in sequential order.

Bogeyman (facing opposite)

This sequence of images explores fear in a similar way to a movie storyboard, but packs in more detail. A child's nightmare comes alive, as the spooky coat and hat become a real bogeyman when the young girl falls asleep. The narrative is clear, but the viewer is left uncertain as to whether it is real or imagined.

Photographer: Duane Michals.

Technical summary: None available.

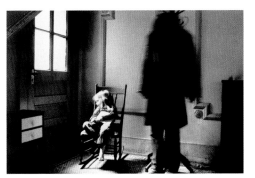

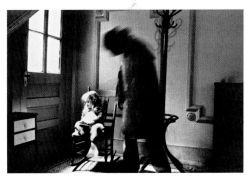

« The decisive moment **Sequences** Case study »

This exploration of time, place and movement was part of a degree course project for photographer Andy Clarke. Wishing to record part of a journey as a continuous 'still' image, Clarke used a conventional camera in an unconventional way to 'record' an entire 36-exposure length of 35mm film in one long exposure. Loading the film in the camera – with the lens cap on – he wound-on every frame, releasing the shutter each time until he reached the end of the roll. (To reduce the possibility of fogging it's best to use the fastest shutter speed and minimum aperture for this.) Setting the shutter to B (Bulb), he used a lockable cable release to trip the shutter and lock it open.

When he wanted to record the scene, Clarke took the cap off the lens and immediately began to walk while rewinding the film back into the camera. He walked at a steady pace with the camera held against his chest in the upright 'portrait' position. The final image shows faintly a narrow cobbled street with its gutters to the sides showing as two lines that run through most of the image. A few tests were required to achieve an appropriate exposure; Clarke worked out that for his camera it was roughly three seconds per conventional frame, which meant about one and a half rotations of the rewind crank per frame or two full rotations for every three steps. When the film ran out, the shutter was closed by unlocking the cable release and the film processed conventionally.

Depending on the precise technique chosen, the results can vary from a detailed strip image that unfolds space, to the impressionist recording of the passage of time and space shown in the continuous 35mm film strip here. Robert Doisneau's memorable image of twisted dancers (reproduced on page 56 of my book *Basics Photography: Exposure*) was produced using a slit shutter in front of the lens of a large-format camera. Andrew Davidhazy's wrap-around portraits and nudes are well worth seeking out and readers interested in full and further details of related techniques are recommended to look at Maarten Vanvolsem's recent book *The Art of Strip Photography: Making Still Images with a Moving Camera*.

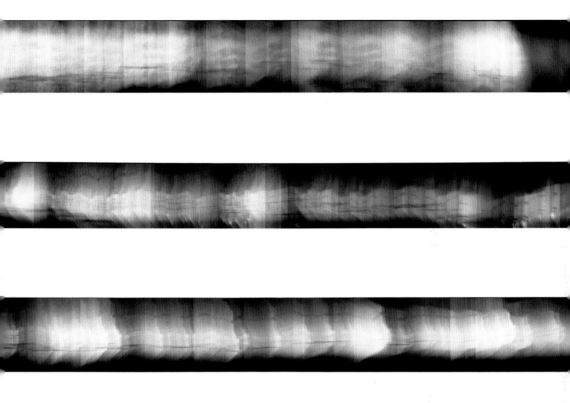

ContactSheet-004 (above)

A photographic exploration of time, place and movement undertaken with a conventional 'stills' camera used in an unconventional way.

Photographer: Andy Clarke.

Technical summary: Olympus OM-10, Zuiko 50mm f/1.8, Kodak Gold 400 using a x10 ND filter.

Conventional technical exercises help you work with photography, your camera and time. These are often based around using the camera as a time-slicing device or exploring the motion-freezing effects of fast shutter speeds or flash. Alternatively, the camera can be used to integrate a portion of time in one exposure, which may involve the use of Neutral Density filters. You can pick up these exercises in books on photographic technique.

But the idea of re-photography builds on a far bigger and more concrete depiction of time. It involves visiting the location of pre-existing images and making another image at that same location but at a different time. Presentation styles vary – two prints or sequences can be presented sequentially or in parallel. One of my foundation students was inspired to re-photograph a complete city street by seeing images made by a photographer in the 1970s deposited in a local history collection. She presented this as a continuous 'joiner' to be seen alongside copies of the original images.

The Second View and Third View re-photographic surveys of the American West are probably the best-known re-photographic projects, duplicating viewpoint and lens geometry with mathematic precision while attempting to match lighting and time of year. Russian photographer Sergey Larenkov uses combat photographs from the Second World War taken across Europe (http://sergey-larenkov.livejournal.com/). He re-photographs the same locations today and selectively blends two images in chilling 'then and now' montages. Exploring the same historic era, photographer Shimon Attie uses pre-war photographs of the Jewish neighbourhood, its people and shops projected onto the real locations where the original images were taken. Photographs of the 'installations' were used as images for his book *The Writing on the Wall – Projections in Berlin's Jewish Quarter*.

My own practice has involved blending images I have taken at the same spot over 20 years apart to create short video clips. I have also blended images of myself on every piece of security ID and school photo I possess to create a looping movie of ageing.

This exercise uses an historic image blended with a recent image taken in the same location using Photoshop layers and masks. You could use postcards, newspapers or old family photos as a source of imagery. Your 'then and now' could be real or imaginary. Choose whether to blend past into the present or present into the past.

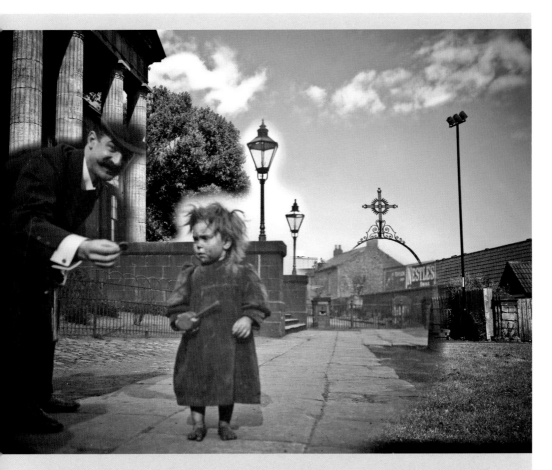

Child beggar, All Saints Church, Akenside Hill, Newcastle-upon-Tyne, UK (above)
An unknown Newcastle photographer made this clearly staged photograph around the turn
of the twentieth century, the negative rescued from the trash when a local studio closed.
Research finally revealed the location, though the ground where the photograph was taken
had been remodelled. A work print helped establish the coverage and viewpoint, which was
matched as closely as possible.

Photographer: Unknown photographer/David Präkel.

Technical summary: Scan from 3½ x 4½ in (quarter-plate) glass negative with photomerged background from
three images all Nikon D700 28-105mm f/3.5-5.6 AF-D Zoom-Nikkor at 56mm, 1/400 at f/10, ISO 200.

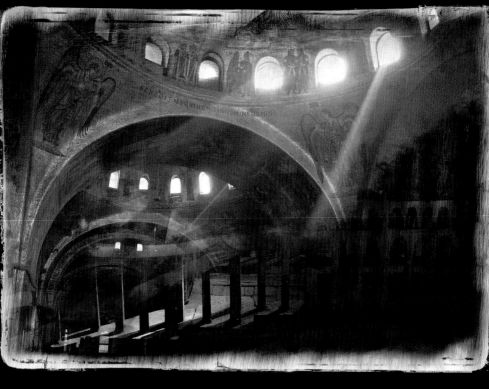

**'Trust that little voice in your head that says
"Wouldn't it be interesting if..." and then do it.'**
Duane Michals (American photographer)

Originality

In this section, we consider how to develop a personal style, to discover ways to create inventive and thought-provoking images. We'll look at the importance of knowing in advance what kind of image is required from a photographic situation, and finding solutions to photographic problems before you even pick up a camera.

The 'Explore, isolate, organize' section looks at the mechanism of composition suggested by German-American photographer Andreas Feininger, which promotes visualization (picturing beforehand what you want), 'working' the subject to develop new photographic solutions and using simple compositional rules to give order and coherence to an image.

Knowing the rules is one thing, but what happens when the photographer breaks or bends the 'rules' of composition? We look at techniques for deliberately incorporating imbalance in images by going against the conventions, and methods for creative cropping to create an effect. We explore the use of humour in the image, analysing why we find certain pictures amusing and how you can be best prepared to take advantage of comic photo opportunities. Contrast is another effective compositional tool. We look at the power of contrasting moods and creating contrast between subjects to add tension and dynamism to an image. Colour is an immense subject in its own right, but we'll take a brief look at how to explore photographic colour in an abstract way.

Digital imaging technology moved so many boundaries in photography and created a host of new opportunities for image making. There are advantages and disadvantages to working digitally and using image-editing software and we'll look at this in more detail. We'll conclude by exploring ways to incorporate approaches to composition in your own image making.

Venezia (facing opposite)
Personal vision needs only inspiration. This is a digital composite image of Venice, Italy. Two images were layered with the frame and sepia-style toning applied digitally. The light rays are authentic.
Photographer: Jean-Sébastien Monzani.
Technical summary: Canon Powershot S30 (3.2MPx), 1/30 at f/2.8, ISO 200.

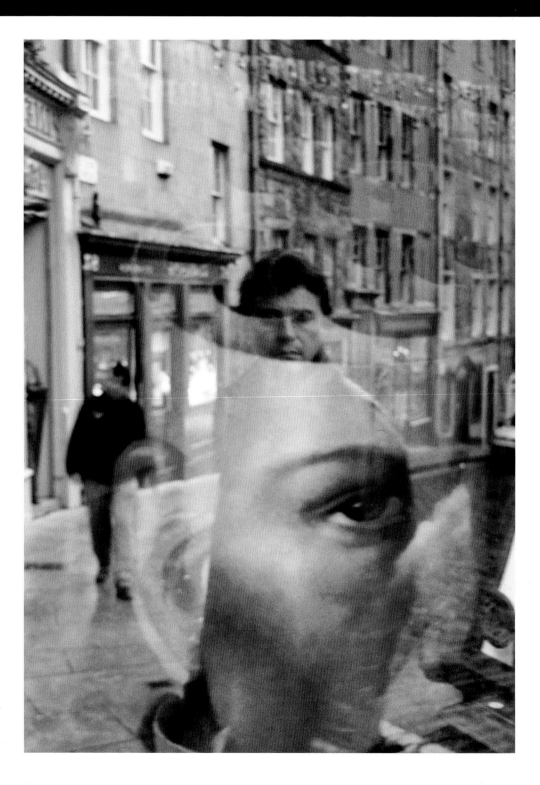

Finding your own view

Developing a personal style is important for every serious photographer, not just the professional. A good way to start discovering your own style is to pick a single subject and to try many different approaches to photographing it. Choosing one topic not only makes the process manageable, but also enables you to explore your subject matter fully and discover how it can be treated photographically.

A prestigious camera course in America once gave attendees only two sheets of handout notes. The first consisted of just three lines: 'One lens. One film. One developer.' The second read: 'Just take the picture.' This was a powerful way of bringing home the point to students that too many photographers lose out by not mastering their equipment. It is so easy to feel weighed down by camera features and technical options that you never get on with the picture-taking itself. To express yourself fluently with a camera – and that is what composition is all about – means that you must be so familiar with the equipment, you could use it blindfolded.

Beyond the initial outlay, digital cameras offer the photographer a no-cost option for experimentation – although, obviously, the entry-level cameras may not offer sufficient technical control for a photographer to make informed choices. Compact digital cameras may be great for travelling and taking snapshots, but are more difficult to learn from. Digital SLRs offer better manual control – and, therefore, flexibility – but are considerably more expensive.

Starting out with a simple manual camera takes a lot of technical complexity out of the equation and allows you to get on with the creative process, to concentrate on the subject and on composition. This allows what you have to say to come through more clearly.

Mind matters (facing opposite)

Mercedes Fages-Agudo began working with reflections while taking a photography class in Massachusetts, USA. Shop-window reflections have since become a theme for her work. These images have featured in exhibitions and in the collaborative book *Second Storey*, which explored the appearance of buildings above street level in downtown Rochester, New York. This portrait of her partner was taken while he was attending a philosophy conference in Edinburgh, Scotland. Turning back, his reflection in the shop window appears appropriately to be issuing from the head on the poster inside.

Photographer: Mercedes Fages-Agudo.

Technical summary: Pentax ZX50 (US) SMC-A 35-70mm f/3.5-4.5 zoom lens, exposure not recorded, Kodak Elitechrome 200.

Finding your own view Contrasts and humour »

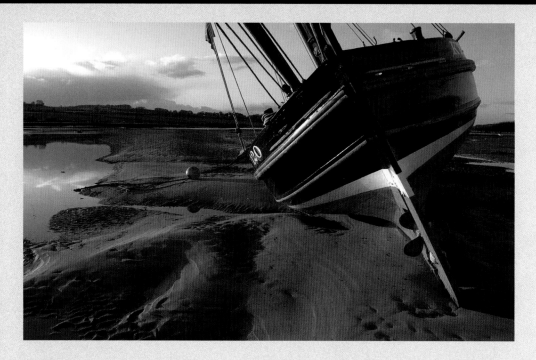

Final image, Alnmouth (above) and working the subject (below)

Moving in line with the keel, the lower viewpoint and tighter crop on the boat provides the strongest composition. The form and texture of mud and hull are perfectly revealed – with rich reflected light from the hull.

Photographer: David Präkel.

Technical summary: 18 exposures in 11 minutes. Nikon D100 18-35mm f/3.5-4.5D AF ED Zoom-Nikkor at 18mm (27mm 35mm equivalent), 1/160 at f/6.7, ISO 200.

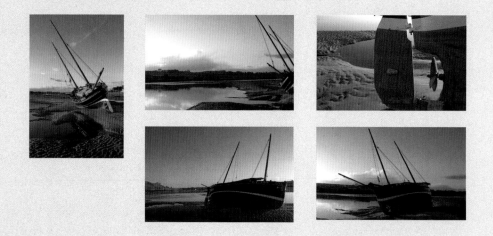

Explore, isolate, organize

It is all too easy to walk up to a photographic subject, lift the camera to the eye, press the shutter and hope to capture what you've seen. Ideally, you should know beforehand what you want the finished image to look like. This is known as visualization (or pre-visualization) and underpins the act of composition.

Photographer and writer Andreas Feininger suggests composition is a three-part process – exploration, isolation and organization. You can prepare for your subject before you even touch a camera or reach the location. If you already know what you intend to photograph, think around the subject in advance. From which angles would you photograph it? How will it change in different lights? How will you cope with movement? By thinking ahead in this way you can solve potential problems.

Exploration

Know what it is about the subject you want to say photographically. Bringing this idea to consciousness is vital, as this will then drive your photographic vision. Exploration of the subject begins and continues with both eye and camera, looking for angles, viewpoints and at how the subject relates to potential backgrounds. If you can, take a range of preliminary images to explore your ideas.

Isolation

Isolation is the process of reducing your options to those that work best. Select the important aspects of the subject using techniques such as selective focusing and depth of field. The aim is to reduce visual clutter and confusion. Choice of lens, viewpoint – even materials – can do this. Once a potential exposure has been established, you can then choose the appropriate combination of shutter speed and aperture to favour either the appearance of motion or depth of field in the final image.

Organization

Organization is the process of choosing the frame and composing the arrangement of the elements within the frame to achieve the finished picture. This is the part of the process that most of us mean when we use the term 'composition'. However, without the important preliminaries of exploration and isolation, this stage may produce a well-ordered image, but one that contains little that expresses your personal vision.

Experimentation and selection (facing opposite)
When you find your subject, work through the process of 'explore, isolate and organize' until you are happy with the result. By way of example, look at the images opposite, which follow this process of experimentation and selection. The texture of the estuary mud, the form of the boat hull, its crazy angle and the quality of late afternoon that was already fading – all combined to catch my attention. Shooting from the shadow side of the hull produced lens flare and wasn't successful. A shot of close-up detail didn't work due to poor viewpoint – the white stripe on the boat hull merges into similarly toned water and there is little detail in the shadows. Tackling the shot from the other end of the boat was no better as the subject became lost in the poorly placed horizon line. Shooting reflections in the water pool was a good idea, but time was running out and the sun sinking quickly. The portrait format is acceptable, emphasizing the angle of the masts, the light now beginning to fully reveal the form of the hull.

Finding your own view Contrasts and humour »

Contrasts and humour

Johannes Itten, a Swiss colour theorist at the Bauhaus school in 1920s Germany, taught that an image that captures and holds the attention must contain a dynamic based on contrast or contrasts. For many, 'contrast' in photography means black and white or dark and light, but there are many alternative ways in which the subject can contrast with the background, or for there to be contrasts within the subject itself. Photographers learn to exploit difference. Bauhaus students were given a list of 'contrasts' and were initially asked to produce pairs of photographs that contrasted with each other. The second, more difficult, stage of the exercise was to combine the contrasting elements in just one image.

This list can be used as a mental exercise to imagine how to incorporate these contrasts into images or it can be used as a basis for creating real images. Some examples are quite straightforward, others more abstract and conceptual. Contrasts can be built into every picture, re-energizing images every time they are seen.

Lamp and contrail (above)
In terms of form, colour and orientation, the silhouetted unlit lamp confronts the aircraft condensation trail left across the sky. The soft, pink glow of a setting sun offers contrast in a city sky.

Photographer: David Präkel.

Technical summary: Leica R4, 180mm f/4 Elmar-R, exposure not recorded, Ektachrome 200 Pro.

Contrast pairs (below)

point – line	large – small	diagonal – circular	rough – smooth
area – line	long – short	straight – curved	hard – soft
line – body	broad – narrow	round – square	heavy – light
area – body	much – little	horizontal – vertical	strong – weak
	many – few	high – low	
still – moving	light – dark	liquid – solid	
continuous – intermittent	black – white	pointed – blunt	
	transparent – opaque	loud – soft	

Psychoanalyst Sigmund Freud theorized that humour was 'the novel juxtaposition of two ideas' – just another kind of contrast. Freud's definition offers photographers a way to create images that are teasingly ambiguous or out-and-out humorous. The choice of viewpoint and picture-taking angle can often align two objects that may seem innocuous separately, but absurd together. This trick is a favourite of press photographers.

Equally productive for the photographer with a sense of humour are opportunities to play with time. Just as we love to solve the puzzle of images with more than one meaning, we take special pleasure in freezing an amusing instance in a single image – what would be considered a 'sight gag' in cinema or on stage. Because of its ability to freeze time, photography can create an enduring joke, in which the inevitable threatens, but never happens; where the visual 'punch line' is hinted at, but never delivered. It is a challenge to consciously create successful humorous images – the images tend to find the receptive photographer rather than the other way around. For photographers, humour, like fortune, favours the prepared mind.

Cloud supporter (right)

Two simple subjects, such as a wall and a cloud, can be aligned so that the cloud appears to rest on the wall for a while. It is not a 'belly laugh' of a joke – nor is it intended to be – but you cannot help but smile every time you see such an image.

Photographer: Todd Laffler.

Technical summary: Sony Cybershot DSC-F717, 1/125 1/125 at f/8.

« Finding your own view **Contrasts and humour** Imbalance »

Imbalance

Photographers can challenge their viewers by intentionally breaking the 'rules' of composition and creating an imbalance in their images. For some, focusing beyond the subject and cropping the subject in an extreme way are techniques that can shift the balance of an image and unsettle the viewer.

Unusual and challenging perspectives are afforded by using a super wide-angle, fisheye or extreme telephoto lens, though the profusion of this kind of image in the media does serve to lessen their impact. This means that photographers have to work harder to find new angles – for example, looking for a viewpoint and angle that disorientates the viewer. Such effects work best if they are exaggerated, so experiment and be bold.

Landscape photographers can disorientate the viewer by removing the horizon from the image, which takes away the usual frame of reference. Moving in to an extreme close-up will abstract the image and reduce the subject to graphic representation. This can be disturbing as it removes all reference to scale.

In terms of colour, fashion photographers long ago began to experiment with the viewer's expectation by cross-processing their films, producing bizarre, but consistent colour shifts throughout their images. Cross processing involves developing a colour film in the wrong chemistry. Digitally, these effects are now quite straightforward to imitate without resorting to chemical effects – it also means you can have a 'straight' version of your image without sacrificing the original. Digital post-processing also means a specific 'look' can be applied consistently across a batch of images.

Skyscraper (facing opposite)

The diagonals and the 'falling' tower block give the viewer the impression that disaster is imminent. The picture imitates the dizzying effect you get putting your head back and turning round to look at the buildings above you in the city.

Photographer: Wilson Tsoi.

Technical summary: Nikon D70 Nikkor 80–200mm f/2.8 AF-D, 1/800 at f/8, ISO 200.

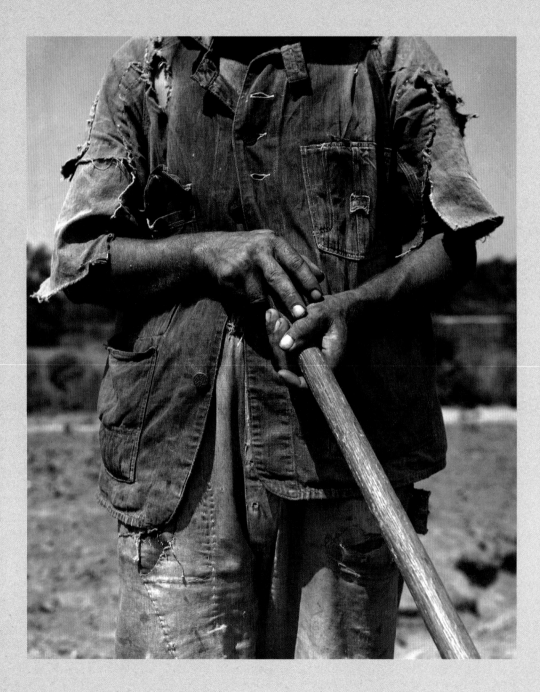

Cropping

In 'Size in the frame' (page 96), we looked at subject placement, cropping and the importance of composing in-camera. Some photographers find it difficult to compose in-camera. While the process has many advantages, there are times when it is best to finesse the crop after the image has been taken. Strong cropping can make an image.

There are two major considerations when cropping. The first is the form of the final image frame; it is worth keeping in mind the proportion of the image when choosing a crop. Of course, this should not prevent you from creating severely cropped images if appropriate to the subject matter and the final presentation. For prints, a pair of good cropping 'ells' with dimensions marked on one-side helps. You can cut your own ells from black card. Computer cropping to a target aspect ratio (and resolution) is straightforward. Image-editing software allows free rotation of the Crop Box, which can be used to either square up an askew horizon or to produce a completely new slant on the image. Composition grids (nautilus spiral, dynamic symmetry, etc.) can be used when cropping with some software.

There is no reason to choose rectangular or square frames when cropping – an asymmetrical crop can create a complete shift in emphasis. Try a trapezoid so that only two sides of the rectangle are parallel. American photographer Robert Heinecken produced puzzle images from sections of cropped prints. Circles and ellipses tend to look dated, as can the soft-edged 'vignette'. It is easy to control these effects digitally and it is well worth experimenting with the technique on certain subjects.

A second consideration concerns placement of the subject in the new image. You can locate the point of interest with mathematical precision, but ideally you should trust your visual instincts and crop around the subject in a way that seems to you to visually 'fit'. If the image is important, mark the crop temporarily with black paper and try living with the cropped image for a while to judge the effect.

Tidying up

The most minimal cropping of an image is still worthwhile, for example to tidy-up or remove distracting or intrusive elements from the edge of the frame – often these are invisible during the picture-taking, particularly with a camera that does not show 100 per cent of the view. If the print is for exhibition, cutting a slightly smaller window in the overlay mat does this form of cropping most effectively.

Hoe culture (facing opposite)

This iconic image of a poor cotton worker was achieved by deliberate hard cropping in-camera to exclude the head. We pay more attention to the clothes and the worker's hands in the absence of the subject's facial features. The hands become the subject's identifying feature, through which the narrative of the subject's life is told. The crop emphatically states that this is not a portrait; the viewer encouraged to see not simply the hardship of the individual, but of all migrant workers.

Photographer: Dorothea Lange.

Technical summary: None available.

Colour

As one of the key elements of composition, pure colour is a subject worthy of exploration in its own right. Colour provides a rich source of opportunity for the photographer, with its strong associations with moods. However, colour is difficult to capture without introducing secondary compositional elements such as shape, texture or form. The truly abstract colour image is hard to find in the real world, and it is a challenging exercise to try to photograph only colour. De-focusing the lens will abstract the image to some extent, though it is often not enough to make the form of the subject sufficiently unrecognizable to leave only the colour. Garden flowers and indoor plants are a great source for this kind of colour composition.

Skies make a perfect subject for abstract colour images. Although the colour range is wide and rich, it will never include certain portions of the colour wheel. With skies, you can be certain that your images will be completely original. Water and reflections offer a wider range of colours, but can be surprisingly difficult to capture successfully with good image sharpness; the water surface is usually much closer than the reflections in it appear to be. (The same problem occurs when photographing a mirror – you can focus on the frame or the reflection, but not both.) To achieve this, you require a small aperture, which means using a longer shutter speed, and this risks a little image movement. However, encountering and solving problems of this kind is part of the enjoyment.

Once you have tackled an obvious source of colour, it becomes easier (and somewhat addictive) to source these interesting qualities in more unusual subjects, such as lichen on a stone wall, which displays an unexpected array of colours – or in the colour of the stone itself. A personal favourite is weathered and peeling paint, which can be found in all kinds of locations – from the boats moored on the quayside of fishing villages to the distressed walls of old cottages.

Rust (below)

This is a landscape. The reality: it is an oil-soaked, rusting engine cover on an excavator. A loose chain has scarred the surface, breaking through the new paint to the older colours beneath.

Photographer: David Präkel.

Technical summary: Nikon D100 60mm f/2.8D AF Micro, 1/200 at f/8, ISO 200.

Digital imaging

Digital imaging technology has rapidly and irreversibly transformed photography. It offers convenience and unlimited scope for image-correction and enhancement, as well as easy experimentation with composition, montage and other special effects. Once in the digital domain, image data becomes completely manipulable. The possibilities are limited only by imagination. However, conventional photography has suffered somewhat.

The impact of digital has meant that film-based companies have axed their product ranges or simply gone out of business, affecting the range of choice for traditional photographers. Digital also impacts directly on composition in terms of visualization. By shifting the emphasis away from capture to post-production it can encourage photographers to rely on a quick-fix approach to image making, rather than perfecting their skills in-camera. Heavily stylized images increasingly replace well-composed ones, and we are in danger of forgetting what the real world looks like. Digital only techniques like High Dynamic Range (HDR) imagery gain popularity and become used too frequently and with no subtlety. It is worth keeping these concerns in mind for your own photography.

On balance, digital imaging does give photographers an ideal opportunity to experiment. However, this is not the same as taking as many images as possible simply to see 'what comes out'. Experimentation is about setting up an idea beforehand, exploring a particular approach and evaluating the results against the original idea. Unexpected discoveries and chance may change the course of the experiment. Unlike film, digital offers photographers the opportunity to instantly review and assess the results at no cost. The same applies to digital post-production work – until you make a print, there is no outlay.

Layers and blending (facing opposite)
Petals and stamens fallen from a yellow poppy flower in the studio suggested the shape of a butterfly. Their pattern was recreated on a light box and two digital exposures were made: one with top lighting and one with transmitted light. The top lighting was directed to cast a shadow above the 'butterflower', like an over-wintering butterfly found by torchlight high up on a wall. The intention was to blend the two digital images as Photoshop layers in a single image to reveal both the delicacy and translucency of the dying petals and their form and texture from the top 'shadow' lighting. The range of final images resulted from using different blending modes and adjusting the opacity of the top layer. The profusion of images suggested a typology (a study of types) of this imaginary 'butterflower' in a presentation, echoing Victorian specimen boxes. The original two images are in the top row and other blended images arranged in a manner appropriate to their density. Unlike real butterflies collected for their endless variation, here the 'specimens' are superficially different, though the content of the images is in fact identical; they are clones.

Typology (facing opposite)
First image, top row: natural light; second image, top row: transmitted light; all other images are combinations of these two using Photoshop layers and blending modes.

Photographer: David Präkel.

Technical summary: Nikon D100 60mm f/2.8D AF Micro, 1/4 at f/8 and 1/90 at f/8, ISO 200.

 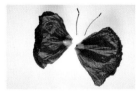 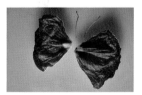

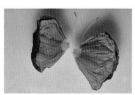 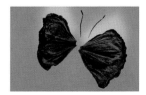 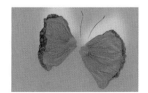

« Colour **Digital imaging** Case study »

Reinvent an old process

Many fine-art photographers are opting to work with old or obsolete chemical or printing processes. Their working practice is built around a chosen technique. This becomes part of the compositional process, as it may be important to consider strong shapes and forms or tonalities, for example, that work well with the medium or technique of choice. Visualizing the end result when composing the picture in the camera is important.

Traditional silk-screen printing gives photographers a way of graphically simplifying images. An image is reduced to simple shapes and tones – each of which is printed in a solid ink colour through a mesh screen. The results can be bold with the substitution of strong colours but there can be a loss of image detail. Silk-screening also requires skills and equipment that some photographers do not want to acquire. As an alternative, image-editing software offers a similar technique, giving bold graphic results while retaining fine detail.

Start with any black-and-white image having strong graphic shapes and a full range of tones. [1] This could be scanned from a darkroom print or be a black-and-white conversion from a digital colour scan or capture. Use the Threshold command to create a series of bitmaps representing tone bands in the image. Each resulting 1-bit bitmap stores only black or white information. Save each file separately. The three bitmaps created for this print represent the light grey, dark grey, and almost black tones of the image. [2, 3 and 4].

Colorize the bitmap images using the Hue Saturation and Lightness command. To create the final image the individual files [5, 6 and 7] can then be printed as solid colours on a single sheet of paper in three passes through a printer. Slight mis-registration between the colours can be a bonus but you have to fight hard to achieve that given the repeat accuracy of modern ink-jet printers.

1

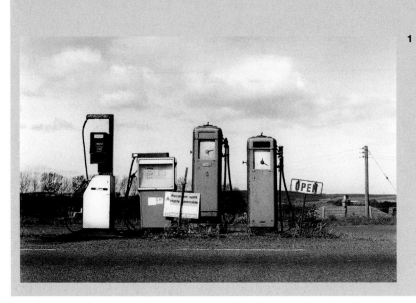

2, 3, 4

5, 6, 7

Filling station (below)

An old filling station in the far north of England, a digitally printed 'silk-screen' image composed of three colours chosen by personal associations with the colours of fuel company logos and rust, based on an original black-and-white darkroom print.

Photographer: David Präkel.

Technical summary: Nikon FE Nikon 50mm f/1.4, exposure not recorded, Ilford FP4 Plus ISO 200.

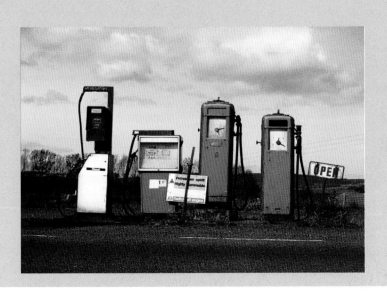

Working with so-called 'found' images – bought through Internet auctions or at tabletop sales – is becoming very popular. Many buyers simply collect images on a theme: photo-booth images, pictures with shadows of the photographer in them, vintage wedding or confirmation pictures. For others, these photographs can be a rich source of new compositional material for montage or, as here, for narrative sequences. Can it ever be 'legitimate' to compose with other people's imagery? Of course.

The images here are part of a project by Mort Marsh, who has been working to create fictional chronicles – a description of a particular series of events. Her aim is to compose 'documents' that can be read and re-read in any number of ways, allowing the viewer to create their own meaning and narrative from the material. The viewer can work through the material in any order they choose, making their own connections and effectively becoming a participant in the compositional process. Nothing is 'right' and nothing ruled out. Marsh has experimented using both presentation software and websites.

This particular selection – from a much larger body of work – uses personal family photographs, mixed with found and constructed images to produce what is in effect a portion of a fictitious family album. The fact that we have taken this sequence out of its original context re-purposes the images yet again. The aim is to make us question how we use photographs to build, rebuild, deal with and remember family history. There is also a bigger question being asked here. Why in the era of Photoshop and digital post-production, when the meaning and content of images is often uncertain and can be transformed so easily, do we still treat some images as if they are imbued with an element of unquestionable truth?

1

3

2

4

Truth and Lies – In Every Photograph She'd Cut Out His Head. The Family album

Found photographs sequenced to create a fictional narrative.

Photographer: Various unknown.

Technical summary: None available.

« Case study **Exercise**

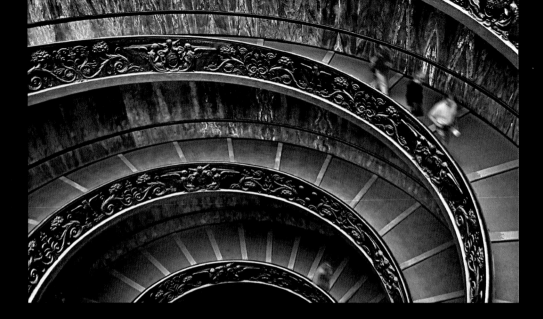

'…the so-called "rules" of photographic composition are… invalid, irrelevant and immaterial… There are no rules of composition in photography, only good photographs.' Ansel Adams (American landscape photographer)

Application

Armed with knowledge about geometry and proportion, how do photographers tackle composition in the real world? In some situations, such as conventional landscape photography, the photographer only has control of certain aspects: having to wait for the right light and being at the mercy of the weather. Choice of viewpoint is also critical. In contrast, the still-life photographer has everything under their control: from subject arrangement to lighting. Still-life photographers often impose limits on their work by studying still-life paintings or by exploring traditions of the medium – for example, photographing a single flower. Fine-art photography shares some similarities with still life, irrespective of its subject matter, as the image is specifically created for artistic purposes. Artist/photographers often explore and apply alternative photographic methods or revive early techniques.

Portraiture is an enduring subject for photography. Many portraitists are motivated by the endless variations of the human face. Moving out of the studio into the sitter's own environment opens up the possibilities, revealing more about a subject's personality and interests. As with portraiture, figure work – depicting the nude human form – is equally enduring; the human body is a classic subject for experimenting with shape, light and texture.

Composition is a much more difficult prospect for the documentary or action photographer, but is, if anything, more important in mediating narrative. The greatest images from both genres have come about when technical excellence is combined with vigorous composition. In the commercial world, composition may be the skilful interpretation of another person's visual ideas. In advertising and editorial photography, the dictates of the art director or picture editor are key to what kind of image the photographer takes. An image may have to be composed around a prescribed design.

This final chapter considers how to use the ideas described above in many practical situations to demonstrate how central composition is to the process.

Vatican stairs (facing opposite)

Careful geometric composition is applied to a travel photograph of tourists climbing a great spiral staircase in the Vatican, Rome. Photographic technique is used to blur the moving people, contrasting them with the precision and solidity of the architecture. This also turns the tourists into splashes of colour in the overall achromatic view, adding a degree of drama and showing the photographer's keen awareness of colour.

Photographer: Trine Sirnes Thorne.

Technical summary: Canon EOS 300D (Digital Rebel) Canon ER-S 18–55mm lens, ISO 100, the image was selectively desaturated and the background toned, keeping colour in the subjects on the stairs.

Landscape

Landscape photography incorporates all the elements of composition, but in large scale, which explains its popularity. With landscape composition, the photographer waits for light to reveal texture, such as geological and archaeological features, to advantage. Shape and form are revealed by the illumination of the constantly moving sun and moon over the forms of the land. The changing seasons clothe the land in a wide range of colours.

Landscape composition is not simply the arrangement of elements in the camera frame, but also requires an appreciation that the image can be transformed by changes in lighting over which the photographer has no control. While the photographer has control over the selection of viewpoint, he or she is subject to the will of nature when it comes to lighting and can only wait and observe. The height and direction of the sun determine light in the landscape and that is dictated by the time of day and the season. Some landscapes – such as north-facing coastlines in the northern hemisphere – are never lit by direct sun. Patience is the greatest virtue. 'Sun finder' charts and sun compasses can help establish how sunlight will fall across a given landscape and the best times for landscape photography. Of course careful research in books and magazines helps, too. While these aids provide helpful preparation, a field trip may be the only real solution. Certain locations have very limited times in the year when they can be photographed – when light penetrates a gorge to illuminate a particular feature, for example.

With landscape photography, before the photographer composes the images, he or she must consider a sense of place. This awareness is what motivates the landscape photographer to express emotional responses to the landscape through photographic means. Without this honesty, landscape photographs will lack emotional depth.

Land and sky (facing opposite)

The ultra wide-angle lens, with its massive depth of field, keeps the foreground in sharp focus yet emphasizes the sky, creating deep perspective and enticing the viewer into the image. The patch of snow balances the cloud formation.

Photographer: Marina Cano.

Technical summary: Canon 20D Canon 10–22mm EF-S, 1/125 at f/11, ISO 200.

Landscape Still life »

Still life

Still life is defined as an arrangement of inanimate (lifeless) objects. It has been a popular discipline with painters and photographers – perhaps, in part, because of its adaptability. In this way, still-life composition is in complete contrast to landscape photography. With a still life everything is under the photographer's control, from the choice of subject to the background and the quality of light. For this reason alone, it requires more discipline, as there are many more variables to play with. It is worth studying the great still-life painters. Look principally at the compositional balance created in their arrangements and how they handle light.

Many photographers approach their still-life subjects as simple, geometric solids (cubes, cones, spheres). Some have practised with little more than a set of wooden or paper forms and a single light source. In fact, almost any object will do for still life, as it is shape and form that is of principal interest. The ideal way to work is to create an arrangement, choose the viewpoint, and then light the still life. For quality and control, it is still best to work with a large-format camera. It is easier to use a 5 x 4in transparency mask as a

frame to establish the viewpoint than to drag the camera around. To do this, hold the frame in front of one eye at roughly the same distance as the focal length of the lens you intend to use.

The simplest lighting is from a single light source, accompanied by a reflector to control the lighting ratio across the set. The background can be lit independently. Though the greatest still life control comes from having mastery of the studio lights, still life outdoors can be even more rewarding, using only the natural light and perhaps a corner of a garden as a setting for pre-selected props. Artist-photographers such as Andy Goldsworthy and Chris Drury create and record organic still lifes from materials found in the environment. Their approach and choice of location is diverse and can include found still lifes in such locations as street markets and the corners of potting sheds.

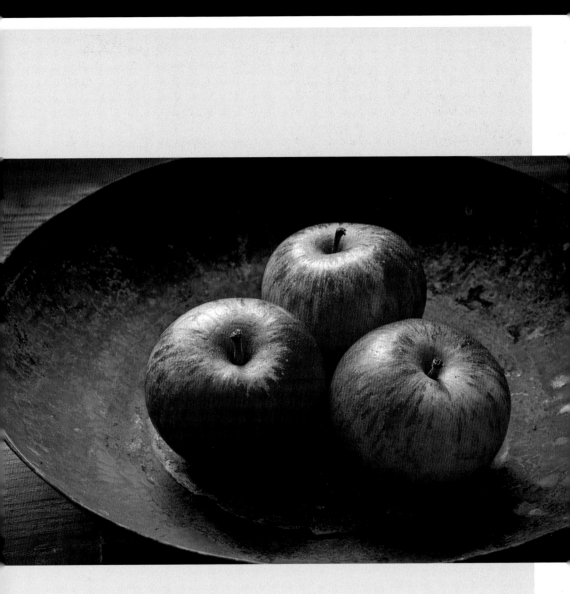

Apples in a copper bowl (above)

Close cropping, exquisite lighting and careful choice of contrasting colours makes this still life stand out.

Photographer: David Milnes.

Technical summary: Canon EOS5D Canon EF24–105mm, f/4L IS USM at 65mm, 1/15 at f/18, ISO 600.

« Landscape **Still life** Portrait »

Portrait

The human face is endlessly fascinating. It is a given form with infinite variations. Portraits can be handled in either a formal or a candid style. In a formal portrait, the sitter and photographer have a consensual understanding of the event and usually work together to create the image. Candid portraits are taken when the subject is unaware of the photographer and is more relaxed and natural. Both kinds of portraits are revealing in different ways.

Though studio work is often more closely associated with formal portraits, good candid pictures can also be taken in the studio. Formal portraits can also be taken on location away from the studio. Simple window light and a reflector can be all that is needed for a formal portrait of a sitter relaxed in their own surroundings.

To find the 'essence' of a personality it is often most effective to concentrate solely on the face, excluding clues from clothing and posture. Environmental portraiture, in contrast, includes the subject's surroundings to provide contrast and context, such as their occupation or passion, to reflect their status.

Photographing two or more people formally or informally can be a challenge. How the sitters use their personal space and respond to each other affects how the viewer interprets the image. Individuals positioned too closely together may appear to be tense and uncomfortable, despite their 'fake' smiles. With subjects who are known to each other, the photographer can explore the dynamics of their relationship.

Sisters (facing opposite)

The tightest of in-camera crops captures a moment of intimacy between two sisters, made all the stronger by showing only one half of each face – there is a whole face in this picture, but it belongs to two people! Cutting out the background and details of clothes and hairstyles creates a timeless quality.

Photographer: Nina Indset Andersen.

Technical summary: No camera details. Taken in shadow on a very bright, sunny day with a white reflector to add modelling to the faces, contrast adjusted in Photoshop and converted to black and white.

Tony (left), and Street Vendor (below)

Portraits of residents of Vancouver's Downtown East Side, an area of extreme poverty in a city that has been described as 'the world's most liveable'. Addiction and disease are rife but Martin's work emphasizes the fact that this is still a 'real suburb home to real people' in compositions that unflinchingly centre the individual in their environment.

Photographer: Claire Martin.

Technical summary: Hasselblad 501CM 50mm f/4 Distagon, 1/125 at f/5.6 and 1/125 at f/4, Ilford Delta 100.

Documentary

Because its subject matter is not primarily aesthetic, the role of composition in documentary photography can be underestimated. Yet it is only well-composed images that will catch and hold the public's attention. Documentary photography is closely linked to photojournalism and reportage, but may not share their sense of 'newsworthiness'. By definition, it is a form of photography that creates a document, a record. Even its practitioners disagree about its objectivity or, as some would argue, lack of it. The contradiction at the heart of documentary photography is that the most meaningful images can only be made through close engagement with, and understanding of, the subject. However, that level of involvement can challenge a wholly objective position. Whatever your feelings about that, it can be one of the most rewarding forms of image making.

Documentary photography is typically project-based, in as much as a photographer will take either a commission or a subject of their choice and create a series of images, usually over a period of time, to document the subject. Despite requiring objectivity, some documentary photographers have a more overtly political agenda and they make this quite clear, while there are those who want to create change by applying pressure via their images – this is the province of the so-called 'concerned photographer'.

Claire Martin – whose work is shown opposite – is a social worker turned documentary photographer and winner of the Inge Morath award (in association with the Magnum Foundation) for her 'ongoing documentation of marginalized communities within prosperous nations'. Her work to date has looked at two very different communities: poverty, addiction and health problems in Downtown East Side Vancouver, Canada and life in a squatter community in the abandoned Marine barracks 'Slab City' in the Colorado Desert, in southeastern California (see page 102).

In conversation with Olivier Laurent of the *British Journal of Photography*, Martin talked about 'trying to create compassionate awareness through visual imagery'. She recognizes the financial difficulties in publishing documentary imagery today and sees awards like the Inge Morath grant as one of the few ways to make this possible.

Figure

We are endlessly fascinated by our own representation – whether faces in portraits, the clothed body, in fashion photography, for example, or with the unique variations of the nude form. The nude has a long and controversial but compelling history, from the human body as classical study of form and light, via glamour photography, to pornography. The approach to, and motivation for, each of these genres may be radically different – from artistic to commercial to exploitative – but any photography of the human body is likely to provoke an emotional response and some kind of debate. The boundaries shift over time with public taste and the law. It is worth considering where the boundaries are for you and your own audience.

There is a difference between a picture of a naked person and a nude. To be naked is to be vulnerable, intimate, whereas the nude is depersonalized. Techniques for photographing the nude often include framing the torso to crop out the face. Facial expressions, like props, can introduce loaded messages into your images. If you do decide to include a person's face, consider that a made-up face and a naked body together may carry an unwanted message. As well as an aesthetic approach, nude photography requires plenty of practical organization: for location, warmth and privacy, and ensuring that there are no marks on the body from underclothes. Consider too whether your sitter – male or female – wishes to be chaperoned.

Compositionally, it is difficult not to be overwhelmed. In the studio, it is best to start with uncomplicated lighting and simple poses – talk through poses with your model before you begin photography, perhaps referencing classic nude images to clarify what you are looking for. Use lighting to reveal the body's form and textures, exploring the abstraction of shape and line or emphasizing sensuality or musculature. Shooting the nude in the landscape requires exceptional skill and careful consideration of matters of taste.

Bodyland (facing opposite)
A precisely observed play of light on the human body, revealing form and texture. Muscle tension and posture move this beyond a simple exploration of the formal elements, introducing drama and potential narrative.
Photographer: Tomas Rucker.
Technical summary: Fuji Finepix S5000 compact, 1/140 at f/2.8, ISO 200.

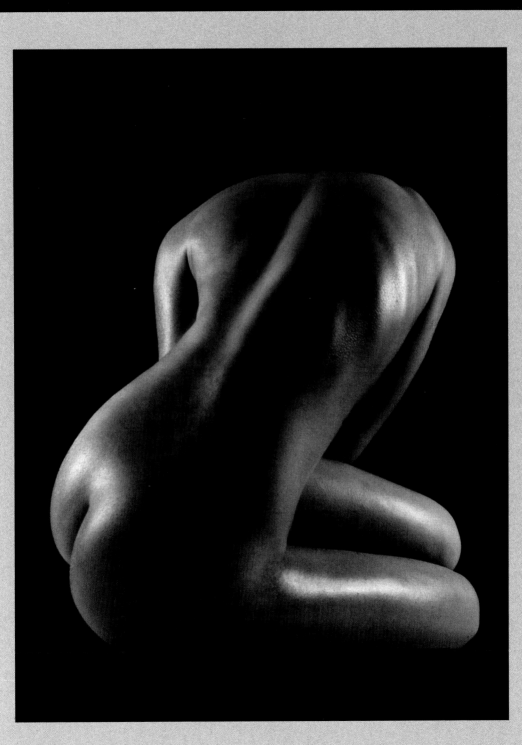

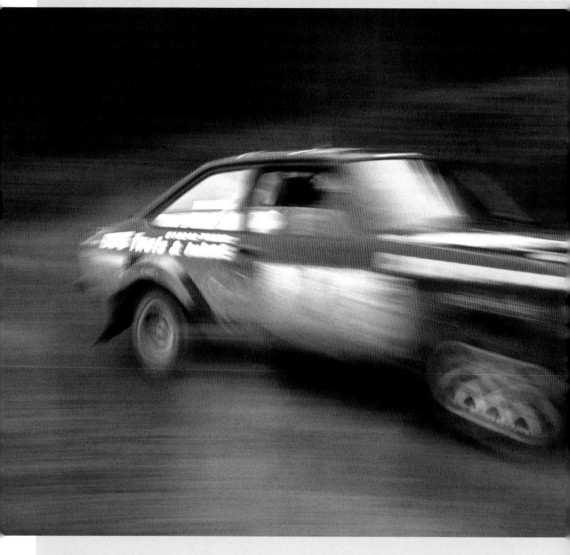

MKII Escort (above)

After his degree, David Elsworth specialized in motorsport photography. This image was taken on the Grizedale Forest Rally, UK, in December 2002. Elsworth explains: 'The Escort was travelling down a straight at around 70mph. The shot was at 1/30 while panning and pulling the lens out from full zoom at 35mm to 19mm.' Elsworth's dramatic, close-up image pitches the viewer into the action. With this image, Elsworth transcends the standard sports image by translating the excitement of the moment.

Photographer: David Elsworth.

Technical summary: Canon EOS 5 Cosina AF 19-35mm f/3.5-4.5 MC, Fuji Sensia 400 film.

Action/sports

Outstanding sporting images transcend interest in the game or sport. They say something about human endeavour or achievement. It is not enough to simply capture the peak of the action. While this may appeal to the sports fan, there has to be an additional element to capture the interest of the general viewer. Strong composition can give action shots this necessary backbone.

To some extent, with sport, the subject matter may be much more familiar to the photographer. The possibilities of play are usually known, but the speed of visualization and an ability to react rapidly to changing events is essential. For the sports photographer, composition must be unconscious and immediate. Simply capturing the event can be difficult enough – as one ex-*New York Times* sports photographer put it: 'If you see it happen in the viewfinder you haven't caught it on film.' Anticipation is everything. Sports photographers need situational awareness and a sixth sense to anticipate the exceptional event before it happens and have the camera there ready to capture it. Visualization can be as important for the sports photographer as the artist; running through imaginary approaches to photographing a game may solve both technical and compositional problems before they are encountered.

Photographers must also be aware of what is going on beyond the field of play. Quite often, collateral events make the great images from sporting moments. These may be happening in the crowd rather than on the field. The great reaction shots are often scooped just before and after play. These images provide the human element, defining the doubts, despair, triumphs and thrills of the moment. Images such as these are the outcome of the photographer's well-honed sense of opportunism.

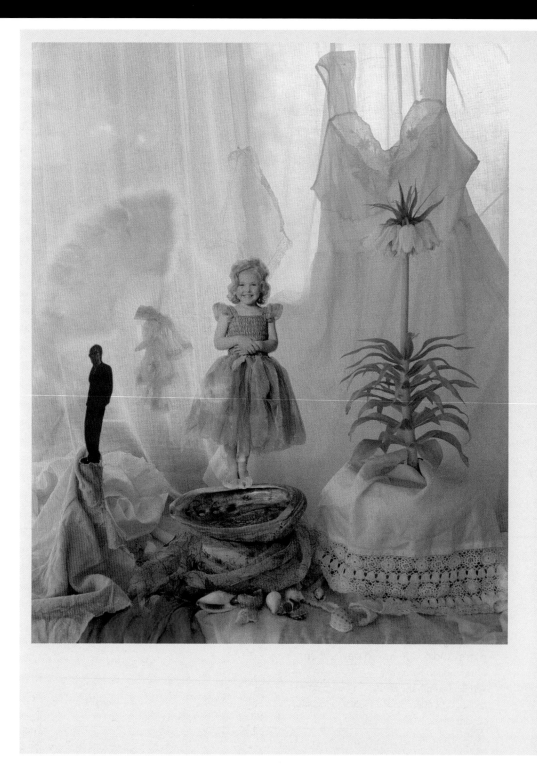

Fine art

Some photographic genres merge or crossover with others and it is often the context of the image that defines it. Fine art photography is a case in point. It is possibly one of the most misunderstood of the photographic genres. For our purposes, fine art photography is that which is undertaken for its aesthetic values alone.

The artist-photographer uses the photographic medium as a vehicle for creative self-expression and their work is often highly constructed to produce particular meanings. This might involve complex manipulations of materials, props, backgrounds and locations or incorporate alternative or historic processes, possibly in combination with digital post-production techniques.

Artist-photographer Karen Melvin is interested in portraiture and self-portraiture. She has worked on a series of still-life photographs on this theme, collectively entitled 'Paper Dolls'. The series explores time, memory and family relationships, connecting the private world of everyday events with the mythology of fairy tales. The 'paper dolls' are black-and-white photographic figures produced by the artist for use in her colour compositions. Working collaboratively with friends and family, Melvin creates improvised situations involving play with costumes and masks to create these figures. The photographic cut-out paper dolls are placed in relationship with other objects in the studio or on location in created 'playgrounds' full of personal associations and connections, inspired by folk tales and myths.

In compositional terms, the images are quite unusual and offer specific challenges for the photographer. They mix two- and three-dimensional objects, which requires careful lighting and sensitivity to focus, scale and proportion. Using photorealistic miniatures with everyday objects enables Melvin to explore the social dynamics in the relationships between family members, old and young, male and female or parent and child. Melvin accesses the fantasy world of her childhood play and reflects on the innocence and fragility of her grandchildren. The still-life arrangements are then re-photographed on large-format colour negative film, the colour rebalanced in Adobe Photoshop and printed as large fine-art prints to exploit the full range of detail. Her work demonstrates the complex relationship between motive and execution required for fine-art photography.

Family (facing opposite)

This image was one of the first in a series of 25 'Paper Doll' images and was made in the artist's studio with mixed daylight and flash.

Photographer: Karen Melvin.

Technical summary: MPP 5 x 4 view camera Fuji NPS colour negative scanned on Nikon LS4500AF scanner. 30 x 40in colour exhibition prints from Epson 7600 wide-format printer on Hahnemuhle Cotton Rag 300gsm paper.

Advertising

Composition plays quite a different role in advertising photography. Composing images for use in adverts requires the photographer to consider how the image may be used beyond its taking. Will text be overlaid on the image? Will the image work alongside other images? Will it be used for magazine publishing or on the Web?

Photographers have tended to use large-format view cameras for this kind of work, as they offer complete control of perspective and depth of field – regardless of whether they are equipped with a film or digital back – and because the image size is already large, they produce the highest-quality images. Elements such as headlines or copy must be incorporated into the overall look of the image. Even in the digital era, tracing paper and wax crayons are still used to plan complex images where space needs to be created for text overlaying an image or for

a secondary image or illustration. The large ground-glass screens of large-format cameras make this easy though increasingly this is done on-screen from a 'tethered' digital camera.

Without their supporting texts and design elements, advertising images can look quite unbalanced, with lots of space around the frame and what may appear to be large empty areas. The photographer must consider using an appropriate density of tone or contrasting colour so that any text can stand out clearly against the image, especially if the image is to be used behind text. The art director usually dictates the required look and the photographer must respect this choice when shooting and lighting in the studio. Placing text onto an image can have a dramatic effect on the perception of depth and needs to be taken into account early on in the process.

Anti-smoking health and beauty (facing opposite, top)

A strong visual health message delivered through contrasts. The perfect symmetry of the jar and the dynamic angle of the cigarette butt; the soft, light tones and the dark, sharp image of the ash add to the tension created by the violent stubbing out of a cigarette in a pot of face cream. It all shouts: 'Smoking will damage your looks.' The incredible detail of a large-format image makes the message even more intense.

Photographer: Kevin Summers Photography.

Art direction: Damian Collins.

Technical summary: 10 x 8 film camera with 240mm lens, Fuji Velvia 50 RVP.

Crystal Cruises Iron (facing opposite, bottom)

A clever and direct visual metaphor where the smoothing iron serenely steams through a sea of blue fabric. The crop adds immediacy and tension.

Photographer: Kevin Summers Photography.

Technical summary: 10 x 8 film camera with 240mm lens, Fuji Velvia 50 RVP.

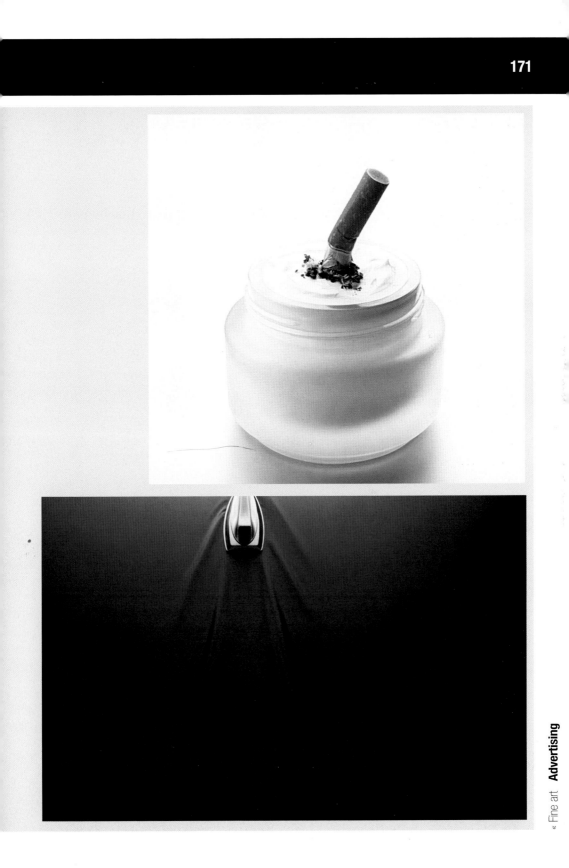

Before composing a picture, first compose your own thoughts. Finding a moment to reflect on the subject – to be true to the emotions it produces in you – will inform your photography. A calligrapher may spend many hours in preparing themselves and their materials before executing one character that seems done in the instant. Photographic composition should follow this process of contemplation and execution.

At first, the process of composition appears cumbersome. It takes conscious effort and it takes time. Many photographers find this puts a brake on spontaneous picture-taking, so they give up on composition, hoping that inspiration will somehow show them favour. However, quality picture-making requires much more than hope of finding significance in the outcome. Good composition never comes about by accident.

By persevering with the deliberate analysis of every image-making opportunity, by identifying each of the formal elements and then weighing the importance of each against your own intentions, the process will eventually become automatic. You will soon become unaware of the process itself and begin to find your responses to your subject more immediate and successful.

How is this achieved? Look at lots of images by other photographers and observe the way in which they use the elements of composition. But most of all, it's achieved by experimenting with each of the elements, singly and in combination (colour and shape or form and texture, for example), and by thinking of the principles of composition as a source for personal expression, not as setting limits on creativity. Learn the rules, and then learn how to bend them. But do not confuse technique with inspiration and never forget content.

So finally, always ask: 'Why am I photographing this?' The answer will inform your image-making and improve your pictures. The more images you make and the more images you look at, the more composition will become a natural part of your picture-taking and will, in the end, look after itself.

Bibliography and webography

General photography, intent and critique
Badger, G. (2007) **The Genius of Photography**. Quadrille Publishing Ltd, London. (also as a DVD of the BBC series).
Barrett, T. (2011) **Criticizing Photographs**. McGraw-Hill, NY.
Berger, J and Jean Mohr. (1995) **Another way of telling**. Vintage Books, NY.
Bright, S. (2006) **Art Photography Now**. Thames & Hudson, London.
Cotton, C. (2009) **The Photograph as Contemporary Art**. Thames & Hudson, London.
Crist, S. (2008) **The Contact Sheet**. AMMO Books LLC, Pasadena, CA.
Dyer, G. (2007) **The Ongoing Moment**. Abacus, London.
Grange, A.I. (2005) **Basic critical theory for photographers**. Focal Press, Amsterdam.
Hill, P. & Cooper, T. (1998) **Dialogue with Photography**. Dewi Lewis Publishing, Stockport.
Jaeger, A.-C. (2010) **Image Makers, Image Takers: The Essential Guide to Photography by Those in the Know.** Thames & Hudson, London.
Marien, M.W. (2010) **Photography: A Cultural History**. Laurence King, London.
Shore, S. (2010) **The Nature of Photographs: A Primer**. Phaidon, London.
Zakia, R.D. (2007) **Perception and Imaging: Photography - A Way of Seeing**. Focal Press, Amsterdam.

Technique and composition
Belt, A.F. (2011) **The Elements of Photography: Understanding and Creating Sophisticated Images.** Focal Press, Amsterdam.
Feininger, A. (1975) **Principles of Composition in Photography.** Amphoto, Garden City, NY.
Hirsch, R. (2009) **Photographic Possibilities the Expressive Use of Equipment, Ideas, Materials, and Processes.** Focal Press, Amsterdam.
Vanvolsem, M. (2011) **The Art of Strip Photography.** Leuven University Press, Leuven.

Photographers and projects that inspire
One of the most inexpensive but comprehensive ways to discover the work of leading photographers is through Thames & Hudson's **Photofile**. Each book features up to 60 images with a well-written and authoritative introduction and artist bibliography.
Brougher, K. (2010) **Hiroshi Sugimoto**. Hatje Cantz, Berlin.
Frank, R. & Kerouac, J. (2008) **Robert Frank: The Americans.** Steidl, Göttingen.
Lesy, M. (2000) **Wisconsin Death Trip.** University of New Mexico Press, Albuquerque, NM.
Michals, D. (1997) **The Essential Duane Michals.** Thames & Hudson, London.
Mora, G. & Hill, J.T. (2004) **Walker Evans: The Hungry Eye.** Thames & Hudson, London.
Penn, I. (2001) **Still life.** Bulfinch Press, Boston.
Squiers, C. (2009) **Avedon Fashion 1944–2000.** Abrams, NY.
Testino, Mario (2002) **Portraits.** Bulfinch Press, Boston.

Websites
http://www.luminous-lint.com/
http://masters-of-photography.com/
http://www.photographysites.com/
http://pdngallery.com/legends/
http://www.magnumphotos.com/
http://www.photojournale.com/

John Chervinsky - extraordinary explorations of time and space, photography and painting
http://www.chervinsky.org/
Andrew Davidhazy - unique imagery created with a wide variety of techniques
http://www.davidhazy.org/andpph/pictures.html
Rephotography
http://sergey-larenkov.livejournal.com/
http://www.thirdview.org
Documentary
http://www.clairemartinphotography.com

Page numbers in *italics* denote illustrations.

A

advertising 170, *171*
aesthetics case study 86, *87*
Agave flower 112
Allen, Jim *10*, *73*
Alnmouth 7, *138*, 139
Ambiguous 54
Andersen, Nina Indset *19*, *62–3*, *125*, *161*
Anti-smoking health and beauty 171
Apples in a copper bowl 159
application 154–71
Artefact 28
Attie, Shimon 132

B

balance 52, *53*, 108–11
Balance 53
Barclay, John *77*, *104*, *105*
Barn door 105
basics 8–33
Beach forms 57
Benidorm, Spain 1997 78
Berndt, Markos *14*
Beyond fashion 111
Binette 12 3
black and white photography 82, *83*, 150, *150*, *151*
Bodyland 165
Bogeyman 129
Boy sailor 30, *31*
Bronze Mary Jane 55
Bus form 108

C

Callahan, Harry *47*
cameras, types of 98, 137, 170
Cano, Marina *156*
Carrshield 101
Cartier-Bresson, Henri 98, 99, *99*, *126*, 127
case for composition 10–13
Child beggar 133
Cityscape 90
Clarke, Andy 130, *131*
Cloud supporter 141
Coimbra, Jorge *38*, *51*, *53*
Coll, Stephen *29*, *57*

Collins, Damian *171*
colour 17, *34*, 74–85, 142, 146, *146–7*
ContactSheet-004 131
contrasts 70, *70*, *71*, 140–1, *140–1*
Cornflower 96
cropping 17, 21, *31*, 97, *144*, 145
Crystal Cruises Iron 171
Cupcakes 119

D

Dancers flow onto the stage 122
Davidhazy, Andrew 130
decisive moments *126*, 127
depth of field 98, 114, *114–15*, 118, *119*
Dias, Nana Sousa *3*
digital imaging 148, *149*
Dockland development 101
documentary *162*, 163
Doisneau, Robert 130
Driftwood 65

E

Ee, Alec *24*
Eleanor 1947 47
Elsworth, David *44–5*, *114–15*, *166–7*
Emilie 62–3
Estima, Tiago *23*
exposures 124, 128
long *122*, 123, 130, *131*

F

Fages-Agudo, Mercedes *136*
Fakhreddine, Karl *39*
Family 168
Fibonacci 18, *19*
figures 164, *165*
Filling station 150, *151*
film type and aspect ratio 92–3, *92–3*
fine art photography *168*, 169
Fjellestad, Marthe *87*
focal length 26, *27*
focus *112*, 113, *113*
Foggy evening 83
foreground and background 114, *114–15*
form *34*, 56–61

formal elements 34–89
format 100–5
'found' images 152, *152–3*
frames 92–107
Friedlander, Lee 107

G

Galeries LaFayette 12
Gibson, Ralph *55*
Grain tower and power lines 42
Grand Prix 44–5
groups 40, *40*, *41*
Grove Rake mine 66
Guang, Lu *94*

H

hand colouring *80*, 81
Happy Sunday morning 125
Heinecken, Robert 9, 145
High Dynamic Range 148
Hockney, David 60, *61*
Hoe culture 144
horizon line 22, 29, 42, 142
HSL colour model 79
humour 141, *141*

I

Ian washing his hair 61
image-editing software 15, 24, 59, 70, 79, *79*, 81, 116, *117*, 150, *150*, *151*
imbalance 142, *143*
in-camera composition 98, *98*, *99*
in-camera cropping 17, *31*, *144*
iphoneography 104
Is here no telephone? 117
ISO 100214 68–9
Itten, Johannes 140

K

Kippford 79

L

Laffler, Todd *141*
Lamp and contrail 140–1
Land and Sky 156
landscape photography 29, 81, 100, *101*, 103, 107, 114, 118, 142, *156*, 157
Lange, Dorothea *144*
Larenkov, Sergey 132
leading lines 48, *49*

Acknowledgements and credits

I would like to acknowledge the debt owed to Alan J. Lefley who taught me a great deal about photography and design while never formally being my teacher. Thanks are due also to staff and members of the Community Darkroom in Rochester, NY, without whose encouragement and support I would never have taught photography.

For the first edition of this book: thanks to those colleagues at the Cumbria Institute of the Arts who generously contributed ideas and images. Thanks also to my students who have always given me at least as many ideas as I have given them. For the new edition: thank you to all the readers who made the first edition of *Basics Photography: Composition* an international success and to Brian Morris of AVA for offering the opportunity to revise and improve the original text. Thank you also to my editor, Leafy Cummins, at AVA.

Finally, thank you to my wife Alison for her continuing support and keen insights: your role too as sounding board and proof reader should never be underestimated.

The publisher would like to thank Frank Balaam.

CREDITS

BASICS

PHOTOGRAPHY

Lynne Elvins
Naomi Goulder

Working with ethics

Publisher's note

The subject of ethics is not new, yet its consideration within the applied visual arts is perhaps not as prevalent as it might be. Our aim here is to help a new generation of students, educators and practitioners find a methodology for structuring their thoughts and reflections in this vital area.

AVA Publishing hopes that these **Working with ethics** pages provide a platform for consideration and a flexible method for incorporating ethical concerns in the work of educators, students and professionals. Our approach consists of four parts:

The **introduction** is intended to be an accessible snapshot of the ethical landscape, both in terms of historical development and current dominant themes.

The **framework** positions ethical consideration into four areas and poses questions about the practical implications that might occur. Marking your response to each of these questions on the scale shown will allow your reactions to be further explored by comparison.

The **case study** sets out a real project and then poses some ethical questions for further consideration. This is a focus point for a debate rather than a critical analysis so there are no predetermined right or wrong answers.

A selection of **further reading** for you to consider areas of particular interest in more detail.

Ethical: aware-
ness/
reflect-
ion/
debate

Working with ethics

Introduction

Ethics is a complex subject that interlaces the idea of responsibilities to society with a wide range of considerations relevant to the character and happiness of the individual. It concerns virtues of compassion, loyalty and strength, but also of confidence, imagination, humour and optimism. As introduced in ancient Greek philosophy, the fundamental ethical question is: *what should I do?* How we might pursue a 'good' life not only raises moral concerns about the effects of our actions on others, but also personal concerns about our own integrity.

In modern times the most important and controversial questions in ethics have been the moral ones. With growing populations and improvements in mobility and communications, it is not surprising that considerations about how to structure our lives together on the planet should come to the forefront. For visual artists and communicators, it should be no surprise that these considerations will enter into the creative process.

Some ethical considerations are already enshrined in government laws and regulations or in professional codes of conduct. For example, plagiarism and breaches of confidentiality can be punishable offences. Legislation in various nations makes it unlawful to exclude people with disabilities from accessing information or spaces. The trade of ivory as a material has been banned in many countries. In these cases, a clear line has been drawn under what is unacceptable.

But most ethical matters remain open to debate, among experts and lay-people alike, and in the end we have to make our own choices on the basis of our own guiding principles or values. Is it more ethical to work for a charity than for a commercial company? Is it unethical to create something that others find ugly or offensive?

Specific questions such as these may lead to other questions that are more abstract. For example, is it only effects on humans (and what they care about) that are important, or might effects on the natural world require attention too?

Is promoting ethical consequences justified even when it requires ethical sacrifices along the way? Must there be a single unifying theory of ethics (such as the Utilitarian thesis that the right course of action is always the one that leads to the greatest happiness of the greatest number), or might there always be many different ethical values that pull a person in various directions?

As we enter into ethical debate and engage with these dilemmas on a personal and professional level, we may change our views or change our view of others. The real test though is whether, as we reflect on these matters, we change the way we act as well as the way we think. Socrates, the 'father' of philosophy, proposed that people will naturally do 'good' if they know what is right. But this point might only lead us to yet another question: *how do we know what is right?*

You
What are your ethical beliefs?

Central to everything you do will be your attitude to people and issues around you. For some people, their ethics are an active part of the decisions they make every day as a consumer, a voter or a working professional. Others may think about ethics very little and yet this does not automatically make them unethical. Personal beliefs, lifestyle, politics, nationality, religion, gender, class or education can all influence your ethical viewpoint.

Using the scale, where would you place yourself? What do you take into account to make your decision? Compare results with your friends or colleagues.

Your client
What are your terms?

Working relationships are central to whether ethics can be embedded into a project, and your conduct on a day-to-day basis is a demonstration of your professional ethics. The decision with the biggest impact is whom you choose to work with in the first place. Cigarette companies or arms traders are often-cited examples when talking about where a line might be drawn, but rarely are real situations so extreme. At what point might you turn down a project on ethical grounds and how much does the reality of having to earn a living affect your ability to choose?

Using the scale, where would you place a project? How does this compare to your personal ethical level?

01 02 03 04 05 06 07 08 09 10

01 02 03 04 05 06 07 08 09 10

Your specifications
What are the impacts of your materials?

In relatively recent times, we are learning that many natural materials are in short supply. At the same time, we are increasingly aware that some man-made materials can have harmful, long-term effects on people or the planet. How much do you know about the materials that you use? Do you know where they come from, how far they travel and under what conditions they are obtained? When your creation is no longer needed, will it be easy and safe to recycle? Will it disappear without a trace? Are these considerations your responsibility or are they out of your hands?

Using the scale, mark how ethical your material choices are.

Your creation
What is the purpose of your work?

Between you, your colleagues and an agreed brief, what will your creation achieve? What purpose will it have in society and will it make a positive contribution? Should your work result in more than commercial success or industry awards? Might your creation help save lives, educate, protect or inspire? Form and function are two established aspects of judging a creation, but there is little consensus on the obligations of visual artists and communicators toward society, or the role they might have in solving social or environmental problems. If you want recognition for being the creator, how responsible are you for what you create and where might that responsibility end?

Using the scale, mark how ethical the purpose of your work is.

01 02 03 04 05 06 07 08 09 10 01 02 03 04 05 06 07 08 09 10

Working with ethics

One aspect of photography that raises an ethical dilemma is that of inherent truth or untruth in manipulating images, particularly with the use of digital cameras. Photographs have, arguably, always been manipulated and at best they represent the subjective view of the photographer in one moment of time. There has always been darkroom manipulation through retouching or double exposures, but these effects are far easier to produce digitally and harder to detect. In the past, the negative was physical evidence of the original, but digital cameras don't leave similar tracks.

While creative photography might not set out to capture and portray images with the same intent that documentary photography might, is there an inherent deception in making food look tastier, people appear better looking or resorts look more spacious and attractive? Does commercial image manipulation of this kind set out to favour the content in order to please, or is it contrary to public interest if it results in a purchase based on a photograph that was never 'the real thing'? How much responsibility should a photographer have when the more real alternative might not sell?

Bernarr Macfadden's *New York Evening Graphic* was dubbed 'the Porno Graphic' for its emphasis on sex, gossip and crime news. In the early 1920s, Macfadden had set out to break new ground and publish a newspaper that would speak the language of the average person. One of the paper's trademark features was the creation and use of the composograph. These were often scandalous photographic images that were made using retouched photo collages doctored to imply real situations. The most notorious use of the composograph was for the sensational Rhinelander divorce trial in 1925.

Wealthy New York socialite Leonard Kip Rhinelander married Alice Jones, a nursemaid and laundress he had fallen in love with. When word got out, it was one of high society's most shocking public scandals in generations. Not only was Alice a common maid, it was also revealed that her father was African American. After six weeks of pressure from his family, Rhinelander sued for divorce on the grounds that his wife had hidden her mixed-race origins from him. During the trial, Jones's attorney had requested that she strip to the waist as proof that her husband had clearly known all along that she was black.

Because the court had barred photographers from witnessing this display, the *Evening Graphic* staged a composograph of Jones displaying her nude torso to the all-white jury. It was made by combining separate photographs of all the people involved and resizing them to proportion. Harry Grogin, the assistant art director, also arranged for an actress to be photographed semi naked in a pose that he imagined Alice would have taken. Grogin is said to have used 20 separate photos to arrive at the one compiled shot, but the resulting picture was believable. The *Evening Graphic*'s circulation rose from 60,000 to several hundred thousand after that issue.

Despite healthy sales, the paper struggled financially because its trashy reputation did not attract advertisers. In spite of the financial position, Macfadden continued to plough his own money into the venture. The paper lasted just eight years – from 1924 to 1932 – and Macfadden is said to have lost over USD$10 million in the process. But the sensationalism, nudity and inventive methods of reporting set a model for tabloid journalism as we know it today.

Is producing fake images of real situations unethical?

Is it unethical to produce images based on sensationalism and nudity?

Would you have created composographs for the *Evening Graphic*?

A photograph is a secret about a secret. The more it tells you the less you know.

Diane Arbus

AIGA
Design Business and Ethics
2007, AIGA

Eaton, Marcia Muelder
Aesthetics and the Good Life
1989, Associated University Press

Ellison, David
Ethics and Aesthetics in European Modernist Literature:
From the Sublime to the Uncanny
2001, Cambridge University Press

Fenner, David E W (Ed)
Ethics and the Arts:
An Anthology
1995, Garland Reference Library of Social Science

Gini, Al and Marcoux, Alexei M
Case Studies in Business Ethics
2005, Prentice Hall

McDonough, William and Braungart, Michael
Cradle to Cradle:
Remaking the Way We Make Things
2002, North Point Press

Papanek, Victor
Design for the Real World:
Making to Measure
1972, Thames & Hudson

United Nations Global Compact
The Ten Principles
www.unglobalcompact.org/AboutTheGC/TheTenPrinciples/index.html